crea

ACTIVITIES

How to Teach Art to Children

AGES 5-11

JOY EVANS
TANYA SKELTONE

AUTHORS

Joy Evans

Tanya Skeltone

CURRICULUM ADVISER

Alison Milford

SENIOR COMMISSIONING EDITOR

Juliet Gladston

ASSISTANT EDITOR

Tracy Kewley

DESIGNER

Geraldine Reidy

PUBLISHED BY

Scholastic Ltd,

Villiers House,

Clarendon Avenue,

Leamington Spa,

CV32 5PR

www.scholastic.co.uk

This edition is published by arrangement with Evan-Moor Corporation, USA. Text © 2004 Evan Moor Corporation

© 2005 Scholastic Ltd

Designed using Adobe Indesign

Printed and bound by Tien Wah Press Ltd, Singapore.

1234567689 5678901234

British Cataloguing-in-Publication Data

A catalogue record from this book is available from the British Library.

ISBN 0-439-96524-1

ISBN 978-0-439-96524-8

Extracts from Programmes of Study from The National Curriculum reproduced under the terms of HMSO Guidance Note 8. © Qualifications and Curriculum Authority.

How to Teach Art to Children

This book is designed to increase children's awareness of different types of art. It gives children a wide range of experiences and helps them to appreciate art around them. Most importantly, it lets them know that there is no wrong way to do art.

How to use the book

The book is divided into two parts. Part one looks at the seven visual elements of art. Part two looks at the way these elements have been used by famous artists, designers and crafts from other cultures.

PART ONE

The art activities in part one introduce the seven basic elements of art: line, shape, colour, tone, texture, form and space. Each section begins with a definition of the element and provides a series of art activities that allow children to experiment with the element. Before or after an activity or project, encourage the children to think about the element by asking these questions:
● Are you aware of the element in everyday life?
● How would your world be different without the element?
● Have you ever used the element to express yourself?

The activity pages in part one are set out as follows:

● Age range

This section highlights the recommended age range. Most of the activities can be adapted for less able or more able children.

● Introduction

This paragraph outlines the techniques covered in the activity and, where appropriate, suggests ways to extend or differentiate the activities for older or younger children.

● Materials

In this section, you will find a concise list of resources needed for each activity. Aim to get the resources ready and set out before the project is started.

● Curriculum links

This section gives direct links to the relevant Government documents such as the National Curriculum and the QCA Schemes of Work. These links can help you with the planning and assessment of future activities.

● Steps to follow

This section gives concise step-by-step instructions on how to carry out the art activity. Some of the instructions include detailed diagrams and information boxes on specific techniques.

● Photocopiables

Some of the activities have photocopiable templates and patterns. These have clear labels and lines to indicate where to cut and trace.

PART TWO

Part two looks at the styles and techniques of famous artists, designers and craftspeople from the past and from different cultures. The art activities allow the children to experience and explore the different elements used in these different artistic styles. To increase the children's knowledge of artwork created by other artists tand craftspeople, collect art reference books and pictures for the children to access and study.

The activity pages in part two are set out as in part one but with the following additions:

● **Artwork**

Each activity shows a photograph of some finished artwork. Show this to the children so that they can see the specific style used by the artist. You may also want to show them an example of the artist's actual work for the children to compare.

● **Background information**

This gives background information about the artist, designer or culture and outlines the techniques used for that particular style of artwork. This information can be for your own use or can be read out to the class before the activity starts.

Differentiation

Most of the activities are suitable for children across Key Stages 1 and 2. There are a few activities that are technically quite difficult and more appropriate for Key Stage 2. It may benefit younger children to see an example of the finished work before they start but it is important to highlight that part of being creative is producing their own individual artwork.

Glossary

At the back of the book is a glossary, which covers the art terms and vocabulary used in the book. The word purple instead of violet has been used throughout the book, as this is the word more commonly used in relation to paints, paper, pens and crayons.

Contents

LINE

Learning about line

There are many ways to use line in artwork. Lines can go in different directions – vertically, horizontally or diagonally. They can be different sizes. They can be thick, thin, solid, broken or jagged and create patterns and textures by changing appearance. They can be bent into curves or broken into angles. There are an infinite number of ways lines can be used. Lines can be made by using a range of tools such as pencils, paintbrushes, pens or crayons. They can help to enhance artwork by adding texture and creating atmosphere and mood.

This section looks at the different ways lines can be used to create fun and interesting shapes and designs. They include the use of vertical, horizontal, diagonal, curved, angled and parallel lines. There are activities such as designing book marks and line designed squares.

Lines of all kinds

Age range: 5-11

Class or large-group activity

This activity introduces the use of lines in artwork. Lines have names to describe their place in space for example diagonal, vertical, horizontal and parallel. Lines can also be thick or thin, solid or broken. For younger children you may want to use simpler terms to describe the direction of the lines such as down and across.

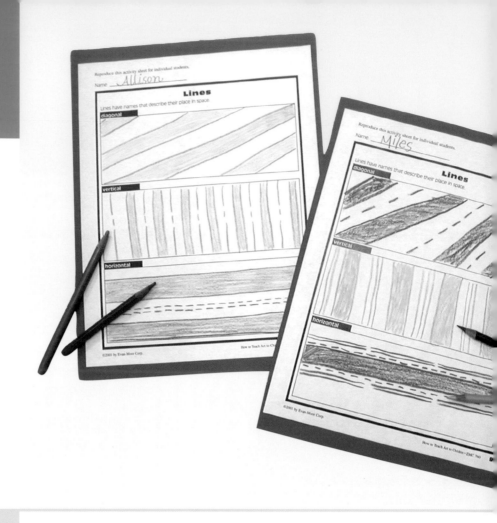

Materials

- crayons or pencils
- a copy of photocopiable page 7 for each child

Steps to follow

1. Ask the children to look around the classroom and to point out examples of lines that they can see.

2. Introduce the words diagonal, vertical and horizontal as ways of describing lines in space. Classify classroom examples of each type.

3. Ask the children to draw one line of each type in the appropriate area on the sheet.

4. Ask them to draw another line parallel to each of the original lines.

5. Let the children shade in the area between the two parallel lines. They will have created a thick line out of two thin lines.

6. Ask the children to add broken lines in each area.

7. Let the children complete their designs by adding more lines and colour.

National Curriculum: Art & design
KS1: 1b, 3a, 4a, 4b, 5b, 5c
KS2: 1b, 3a, 4a, 4b, 5b, 5c

QCA Schemes: Art & design
Unit 3B – Investigating pattern

Scottish 5-14 Guidelines: Art & design
Using materials, techniques, skills and media:
Using visual elements – lines
Expressing feelings, ideas, thoughts and solutions: Communicating

Photocopy this sheet for children to use with Lines of all kinds on page 6.

SCHOLASTIC
PHOTOCOPIABLE

Name _____

Lines

Lines have names that describe their place in space.

Diagonal

Vertical

Horizontal

Line designs

Age range: 5-11

Small-group activity

In this activity, small groups of children plan a design to reinforce their understanding of vertical, horizontal and diagonal lines. This is a fun activity for younger children but you may need to use simpler terms to describe the lines. This activity can also be used as part of a maths lesson on patterns and lines.

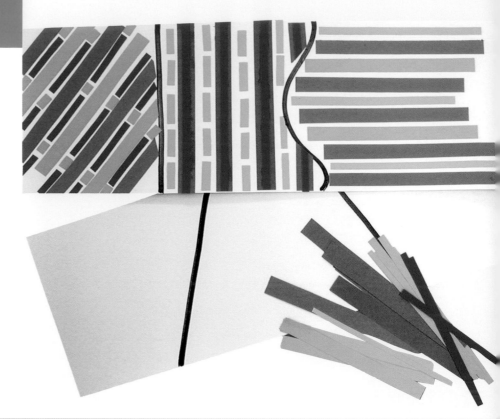

Materials

(for each group)

- 1 metre white lining paper
- 1.5 x 30.5 cm card strips in assorted colours
- felt-tip pens
- glue
- scissors

Steps to follow

1. Divide the class into groups of two to four children.

2. Ask the groups to divide their papers into three areas using black pen. Areas may be any configuration: squares, overlapping shapes or equal parts.

3. Ask them to add cut-paper lines to each area. The lines may be thick, thin, solid or broken but:

 - one area should contain only horizontal lines

 - one area should contain only vertical lines

 - one area should contain only diagonal lines.

4. Children may like to add lines in felt-tip pen to enrich the designs.

National Curriculum: Art & design
KS1: 1b, 2a, 2c, 3a, 4a, 4b, 5b, 5c
KS2: 1b, 2a, 2c, 3a, 4a, 4b, 5b, 5c

QCA Schemes: Art & design
Unit 3B – Investigating pattern

Scottish 5-14 Guidelines: Art & design
Using materials, techniques, skills and media:
Using visual elements – lines
Expressing feelings, ideas, thoughts
and solutions: Creating and designing;
Communicating

Curves and angles

Age range: 5-11

Individual activity

This activity investigates how lines can be bent into curves and broken into angles. At the end of the activity, use the children's work to highlight how lines can create an infinite number of patterns and shapes.

Steps to follow

1. Discuss the different types of lines that can be created by changing a straight line into one that bends or curves, for example:

 zigzag

 wavy

 looped

 curly

 scalloped

2. Ask the children to fold their pieces of card or paper into eight equal rectangles.

3. Invite them to create a different type of line in each box.

Materials

- A4 white card or paper
- crayons

National Curriculum: Art & design
KS1: 1b, 3a, 4a, 4b, 5b, 5c
KS2: 1b, 3a, 4a, 4b, 5b, 5c

QCA Schemes: Art & design
Unit 3B – Investigating pattern

Scottish 5-14 Guidelines: Art & design
Using materials, techniques, skills and media:
Using visual elements – lines
Expressing feelings, ideas, thoughts
and solutions: Creating and designing;
Communicating

Curved or bent?

Age range: 5-11
Individual activity

Use this activity to encourage the children to make use of their knowledge of different lines used in artwork. Ask them to create interesting designs using a range of both curved and straight lines.

Materials

- 15 cm squares of white card – two per child
- large piece of black poster paper
- crayons or felt-tip pens

Steps to follow

1. Give each child two squares of white card.
2. Ask the children to use one of the squares to create a design using only straight, bent and angular lines.
3. On the other square, they should use only curved lines to create a design.
4. When the children have finished, group the designs together for display on the black paper.

National Curriculum: Art & design
KS1: 1b, 2a, 2c, 3a, 4a, 4b, 5b, 5c
KS2: 1b, 2a, 2c, 3a, 4a, 4b, 5b, 5c

QCA Schemes: Art & design
Unit 3B – Investigating pattern

Scottish 5-14 Guidelines: Art & design
Using materials, techniques, skills and media:
Using media; Using visual elements – lines
Expressing feelings, ideas, thoughts
and solutions: Creating and designing;
Communicating

Line delight

Age range: 5-11

Individual activity

This activity investigates how interesting designs can be created with just two lines. The two lines can be the same or different. They can be horizontal, vertical, straight or curved. Encourage the children to investigate how many different designs they could create using the lines.

Steps to follow

1. Challenge the children to create a design beginning with two lines.

 • The lines drawn with black felt-tip pen may be horizontal, vertical or diagonal.

 • Both lines must travel in the same direction.

 • The lines do not need to be parallel. One line may be curved and the other bent.

2. Ask the children to make three or more different designs that fit the above criteria.

3. Ask them to add colour to their designs.

4. The children can then mount their designs on the black paper.

Materials

(for each child)

• four 10 x 13 cm pieces of white card

• 23 x 30.5 cm black paper

• permanent black marker or crayon

• felt-tip pens

National Curriculum: Art & design
KS1: 1b, 2a, 2c, 3a, 3b, 4a, 4b, 5b, 5c
KS2: 1b, 2a, 2c, 3a, 3b, 4a, 4b, 5b, 5c
QCA Schemes: Art & design
Unit 3B – Investigating pattern
Scottish 5-14 Guidelines: Art & design
Using materials, techniques, skills and media:
Using media; Using visual elements – lines
Expressing feelings, ideas, thoughts
and solutions: Creating and designing;
Communicating

Create a maze

Age range: 7-11

Individual activity

For this activity, the children have to tear three shapes from a rectangle and outline the shapes with a continuous line to fill the rectangle. Explain to the children that the activity demands a certain amount of thought and strategy.

Materials

- 21.5 x 28 cm white paper
- 23 x 30.5 cm bright-coloured paper
- fine-tip marker pen
- glue

National Curriculum: Art & design
KS2: 1b, 2a, 2b, 2c, 3a, 4a, 4b, 5b, 5c
QCA Schemes: Art & design
Unit 3B – Investigating pattern
Scottish 5-14 Guidelines: Art & design
Using materials, techniques, skills and media:
Using media; Using visual elements – lines
Expressing feelings, ideas, thoughts
and solutions: Creating and designing;
Communicating

Steps to follow

1. Ask the children to fold small sections of the paper and tear out three interesting shapes. (It may be easier for younger children to glue irregular shapes to the white paper instead of tearing out pieces.)

2. The objective is to draw one continuous line. The children should not cross over a line, but they may make a u-turn and go backwards. Demonstrate to the children how to do this:

 • Using a fine-tip marker pen, begin circling one of the shapes (holes). Before that line comes to a completion, draw towards the next shape.

 • Circle around the second shape, then draw towards the third shape. Continue the line until you have filled the paper.

3. Mount the maze on the bright-coloured paper.

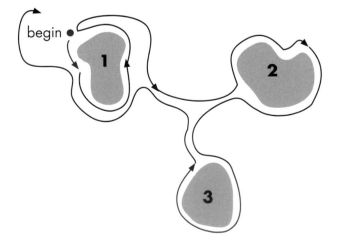

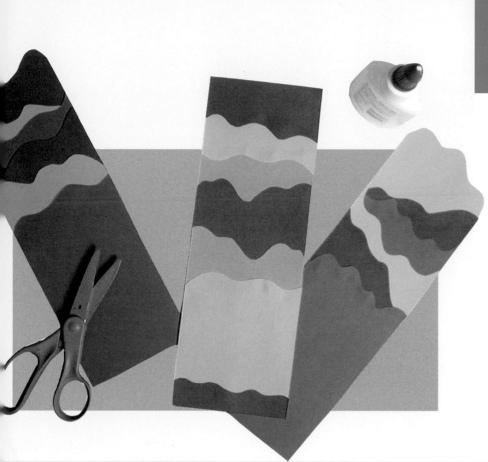

Curved-line bookmark

Age range: 5-11
Individual activity

In this activity, children cut narrow strips of card in a curve and layer the strips to create a bookmark. Use this activity to highlight how the simple use of lines can make interesting and quite complex designs.

Steps to follow

1. Let the children choose three paper strips in different colours.

2. Ask them to cut each strip into two pieces with a curved cut.

3. The children should then layer the pieces to create a bookmark. The straight end should always be placed towards the bottom of the bookmark.

4. Ask the children to glue the pieces together.

5. Laminate the children's work to create a more durable bookmark.

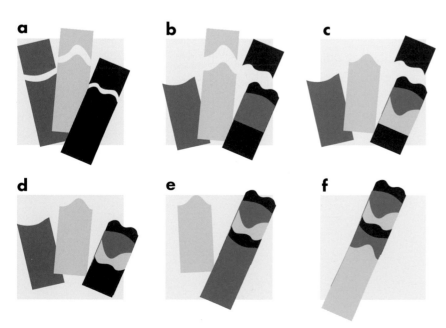

Materials

- 7.5 x 15 cm coloured paper strips
- scissors
- glue

National Curriculum: Art & design
KS1: 1b, 2a, 2b, 2c, 3a, 4a, 4b, 5b, 5c
KS2: 1b, 2a, 2b, 2c, 3a, 4a, 4b, 5b, 5c

QCA Schemes: Art & design
Unit 1B – Investigating materials
Unit 3B – Investigating pattern

Scottish 5-14 Guidelines: Art & design
Using materials, techniques, skills and media:
Using visual elements – lines
Expressing feelings, ideas, thoughts and solutions: Creating and designing; Communicating

SHAPE

Learning about shape

Shape is an essential element of art. Both regular shapes such as squares, triangles, circles and oblongs and irregular shapes have a part to play. These shapes can take on different forms in art; they can be two-dimensional or three-dimensional. In drawings and paintings, two-dimensional shapes can be made to look three-dimensional through the use of skilful shading – and two-dimensional patterns can be turned into three-dimensional constructions. Shape also involves the use of positive and negative space where the background of a shape is negative and the object is positive.

In this section on shape, there is a range of activities that encourage the children to investigate the use of regular and irregular two-dimensional and three-dimensional shapes to create designs. They include collages and making three-dimensional constructions using a pattern.

Line outline shapes

Age range: 5-11

Class or large-group activity

This activity looks at a form of drawing called outline drawing. The children look at simple objects and create the outline of shapes using lines. Explain to the children that the pencil must be kept on the paper whilst drawing.

Steps to follow

1. Give the children pieces of paper and invite them to sketch along with you.

2. Draw a circle, a square and a triangle. Point out that each of these shapes is made up of either curved or bent lines. Each is a familiar basic shape that is created by connecting lines.

3. Look at a simple object such as an apple, a bottle or a vase. Draw an outline of the shapes. (This form of drawing is called contour or outline drawing.)

 • Only the outline of the object is drawn.
 • No inside details are added.

Note: Keep the pencil on the paper while drawing. The resulting drawing may be distorted and exaggerated, but it emphasizes that form is an outline in space that can be manipulated as it is drawn.

Materials

• paper
• pencils

National Curriculum: Art & design
KS1: 1a, 1c, 3a, 4a, 4b, 5b, 5c
KS2: 1b, 1c, 3a, 4a, 4b, 5b, 5c

QCA Schemes: Art & design
Unit 1B – Investigating materials
Unit 3B – Investigating pattern
Unit 5A – Objects and meanings

Scottish 5-14 Guidelines: Art & design
Using materials, techniques, skills and media:
Using visual elements – shape
Expressing feelings, ideas, thoughts
and solutions: Creating and designing;
Communicating

A shape design

Age range: 5-11

Individual activity

In this activity the children create a design using felt shapes and copy the design onto paper. Encourage the children to experiment with creating shape designs using wooden blocks or flat plastic shapes.

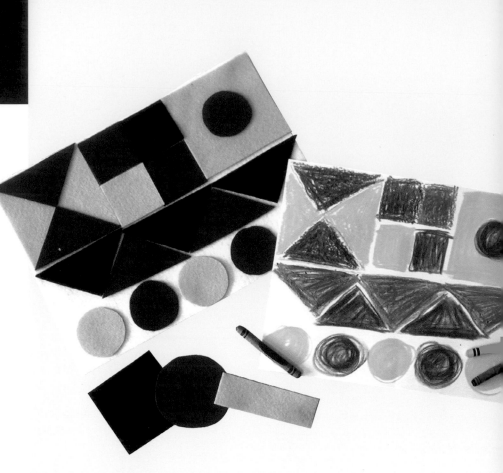

Materials

- flannel board
- felt shapes: circles, squares, triangles and rectangles in red, blue and yellow, cut from squares of equal size
- drawing paper
- red, blue and yellow crayons

Steps to follow

1. Ask the children to manipulate the felt shapes to create abstract designs on the flannel board. They should experiment with many different designs to see which ones they like the best.

2. The children should then re-create the designs they developed by drawing and colouring them on a piece of paper.

National Curriculum: Art & design
KS1: 1b, 2a, 2b, 3a, 3b, 4a, 4b, 5b, 5c
KS2: 1b, 1c, 2a, 2b, 2c, 3a, 3b, 4a, 4b, 5b, 5c

QCA Schemes: Art & design
Unit 1B – Investigating materials
Unit 3B – Investigating pattern

Scottish 5-14 Guidelines: Art & design
Using materials, techniques, skills and media:
Using media; Using visual elements – shape
Expressing feelings, ideas, thoughts
and solutions: Creating and designing;
Communicating

Positive and negative shapes

Age range: 5-11

Individual activity

This activity allows the children to investigate the concept of the positive and negative image in art. Every time a line outlines a shape, it is really creating two images: the positive one that is outlined and the negative one that is background.

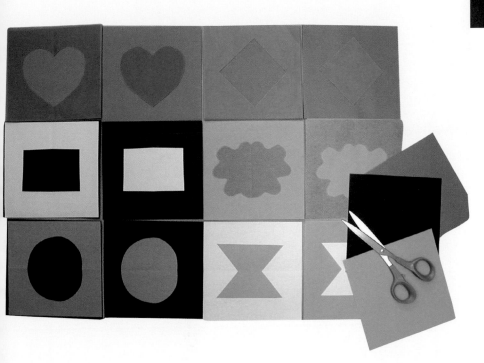

Steps to follow

1. Give each child one square of paper.

2. Ask the children to fold the square in half once and cut a shape out of the centre. They now have a positive and a negative representation of a shape.

3. Let the children choose a square in a contrasting colour and mount the positive and negative shapes on the contrasting squares.

4. Display the designs for others to enjoy.

Materials

- 15cm squares of card or paper in strong, contrasting colours
- glue
- scissors

National Curriculum: Art & design
KS1: 1b, 2a, 2b, 3a, 4a, 4b, 5b, 5c
KS2: 1b, 2a, 2b, 2c, 3a, 4a, 4b, 5b, 5c
QCA Schemes: Art & design
Unit 3B – Investigating pattern
Scottish 5-14 Guidelines: Art & design
Using materials, techniques, skills and media:
Using media; Using visual elements – shape
Expressing feelings, ideas, thoughts
and solutions: Creating and designing;
Communicating

Shape designs

Age range: 5-11

Individual activity

This activity encourages the children to draw patterns inside a positive shape to create a large, bold design. Before the activity starts, make a list with the children of the different shapes they could use.

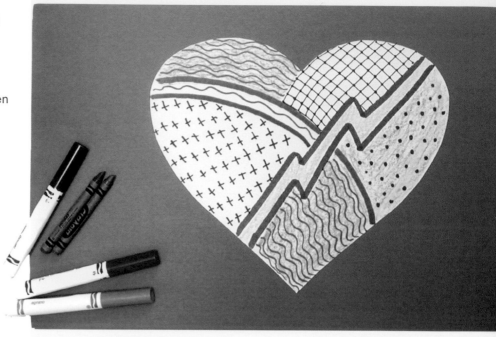

Materials

- 30.5 x 46 cm white card
- 30.5 x 46 cm card in assorted colours
- glue
- scissors
- crayons or felt-tip pens

Steps to follow

1. Ask the children to draw large shapes on the white card and to cut them out. The shapes may be circles, squares, triangles or more complicated contour drawings. It may be easier to fold the paper in half to cut out a symmetrical shape.

2. Ask the children to create a pattern inside the shape. To do this they should:
 - divide the shape into several parts
 - fill each part with a different design or pattern.

3. Mount the shapes on coloured pieces of card.

National Curriculum: Art & design
KS1: 1b, 2a, 2b, 3a, 4a, 4b, 5b, 5c
KS2: 1b, 1c, 2a, 2b, 2c, 3a, 4a, 4b, 5a, 5b, 5c
QCA Schemes: Art & design
Unit 3B – Investigating pattern
Scottish 5-14 Guidelines: Art & design
Using materials, techniques, skills and media:
Using visual elements – shape
Expressing feelings, ideas, thoughts
and solutions: Creating and designing;
Communicating

What is it?

Age range: 5-11

Individual activity

In this activity, each child is given the same shape and asked to design their own picture around it. At the end of the activity, display the pictures to compare the children's ideas. Extend this activity by using different shapes and colours. Older children may enjoy the challenge of using several shapes at the same time.

Steps to follow

1. Ask the children to glue a blue circle onto a white square.

2. Ask them to draw lines around the blue circle to complete a picture. The circle must be a part of the picture.

3. Compare the children's completed pictures. Discuss the different things the blue circles represent.

Materials

- blue card, cut into 5cm diameter circles
- 15 cm squares of white card
- glue
- crayons

National Curriculum: Art & design
KS1: 1a, 1b, 2a, 2b, 3a, 4a, 4b, 5a, 5b, 5c
KS2: 1a, 1b, 2a, 2b, 2c, 3a, 4a, 4b, 5a, 5b, 5c
QCA Schemes: Art & design
Unit 3B – Investigating pattern
Scottish 5-14 Guidelines: Art & design
Using materials, techniques, skills and media:
Using visual elements – shape
Expressing feelings, ideas, thoughts
and solutions: Creating and designing;
Communicating

Shape search

Age range: 5-11

Small-group activity

Regular shapes fit definitions and are given names such as circles, ovals, crescents, squares, rectangles, triangles and trapezoids. Some shapes are irregular and don't fit a definition. A paint spill might be an irregular shape that doesn't fit a definition. This activity could be used as part of a mathematics lesson.

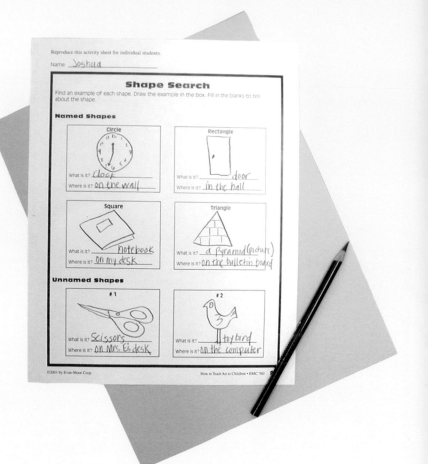

Materials

- a copy of photocopiable page 21 for each child
- crayons or pencils

Steps to follow

1. Divide the class into small groups.

2. Give each child a copy of the photocopiable page.

3. Ask the children to work in the groups to find and name shapes. They should draw examples of the shapes or take photos with a digital camera to document the shapes that they find.

4. Share results of the shape searches with the class.

National Curriculum: Art & design
KS1: 3a, 4a, 4b, 5b, 5c
KS2: 3a, 4a, 4b, 5b, 5c

QCA Schemes: Art & design
Unit 3B – Investigating pattern

Scottish 5-14 Guidelines: Art & design
Using materials, techniques, skills and media:
Using visual elements – shape
Expressing feelings, ideas, thoughts
and solutions: Creating and designing;
Communicating

Name _____

Shape search

Find an example of each shape. Draw the example in the box.
Fill in the blanks to provide more information about the shape.

Named shapes

Circle

What is it? _____

Where is it? _____

Rectangle

What is it? _____

Where is it? _____

Square

What is it? _____

Where is it? _____

Triangle

What is it? _____

Where is it? _____

Unnamed shapes

1

What is it? _____

Where is it? _____

2

What is it? _____

Where is it? _____

A shape collage

Age range: 5-11
Individual activity

In this activity the children cut two identical shapes into pieces. They then put the pieces back together to create a collage. Encourage the children to use the wrapping paper to decorate the shapes with interesting patterns and designs. Younger children may need support in this activity.

Materials

- 23 cm square of coloured card
- scraps of wrapping paper
- scissors
- glue

National Curriculum: Art & design
KS1: 1b, 2a, 2b, 3a, 4a, 4b, 5b, 5c
KS2: 1b, 2a, 2b, 2c, 3a, 4a, 4b, 5b, 5c

QCA Schemes: Art & design
Unit 1B – Investigating materials
Unit 3B – Investigating pattern

Scottish 5-14 Guidelines: Art & design
Using materials, techniques, skills and media:
Using media; Using visual elements – shape
Expressing feelings, ideas, thoughts
and solutions: Creating and designing;
Communicating

Steps to follow

1. Let the children choose two scraps of wrapping paper that are about the same size. Show them how to cut out the shapes as follows:

 - Hold the two pieces together as you cut out a circle, triangle or square.

 - Hold the two identical shapes together and fold the shape in half.

 - Cut out the centre of the shape.

 - Make additional cuts to the remaining shape.

2. When the children have cut out their shapes, ask them to glue the pieces on the card square, using parts of one coloured shape to complete the other coloured shape.

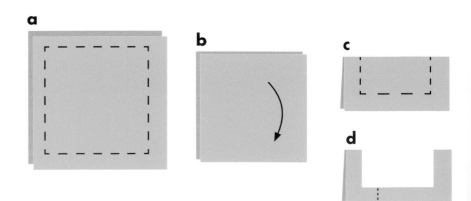

COLOUR

Learning about colour

Colour is a sensation produced by rays of light of different wavelengths. Colour affects and reflects the way we think and our emotions. Children need to develop an understanding of how colours can represent moods, designs and atmospheres by choosing colours that have the right effect. The use of a colour wheel allows the children to see how the three primary colours can be mixed together to make secondary colours and how there are warm and cool colours.

This section on colour looks at the colour wheel and the different colour-mixing techniques that children can use to create effective artwork. Activities involve looking at the three primary colours, secondary colours, the use of contrasting colours, complementary colours and tertiary colours. They use a range of techniques including paper collage, printing, watercolour, pen and paint. Children are encouraged to experiment with mixing or contrasting a range of colours to produce interesting designs and imaginative paintings.

Primary colours

Age range: 5-11

Class or large-group activity

There are three primary colours: red, yellow and blue. They are called primary colours because you can mix them to create all the colours of the rainbow. This activity introduces the children to the three primary colours and their effects.

Materials

- miscellaneous objects in the three primary colours
- red sweater
- colourful classroom

National Curriculum: Art & design
KS1: 3a, 4a, 4b, 5b, 5c
KS2: 3a, 4a, 4b, 5b, 5c

Scottish 5-14 Guidelines: Art & design
Using materials, techniques, skills and media: Using visual elements – colour
Expressing feelings, ideas, thoughts and solutions: Creating and designing; Communicating

Steps to follow

1. Display the three primary colours. Brainstorm things often associated with each colour, for example:

 yellow – sun, lemons, flowers, ducklings
 blue – sky, water, jeans
 red – fire, roses, sunsets, hearts

2. Discuss how each colour has certain feelings associated with it, for example:

 yellow – cheerful
 blue – cool or sad
 red – angry or hot

3. Invite the children to look around the room and identify red objects. Does red look the same each time?

4. Take a red sweater and compare how light or dark the red seems to be depending on whether it is located in a dark closet or out in the sunlight. Help the children to conclude that any colour may be altered by the amount of light that surrounds it.

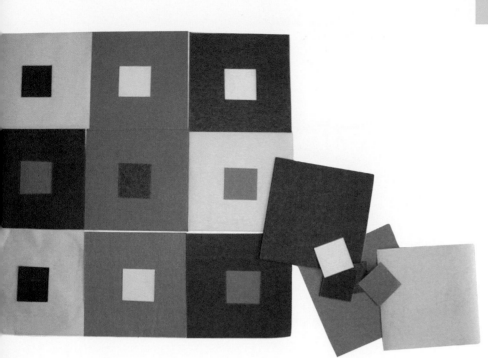

A primary colour quilt design

Age range: 5-11

Small-group activity

In this activity the children work together in groups to create paper quilts using squared card in three primary colours. Encourage the children to experiment with different colour arrangements. Explain that there is no correct way to arrange the colours. It is entirely up to the group's tastes.

Steps to follow

1. Divide the class into groups of two to four children.

2. Ask the children to place the larger primary-coloured paper squares on the background grid.

3. The children should then place the smaller paper squares on top of the large squares. Encourage them to try different combinations before deciding on the final arrangement.

4. Ask the children to glue all the squares in place.

5. Display all the group designs when they are finished.

Materials

(for each group)

- 23 cm squares of card:
 three blue
 three red
 three yellow

- 7.5 cm squares of card:
 three blue
 three red
 three yellow

- 69 cm paper square folded into 23 cm squares to make a background grid

National Curriculum: Art & design
KS1: 1b, 2a, 2b, 2c, 3a, 4a, 4b, 5b, 5c
KS2: 1b, 2a, 2b, 2c, 3a, 4a, 4b, 5b, 5c

QCA Schemes: Art & design
Unit 1B – Investigating materials
Unit 3B – Investigating pattern
Unit 5C – Talking textiles

Scottish 5-14 Guidelines: Art & design
Using materials, techniques, skills and media:
Using media; Using visual elements – colour
Expressing feelings, ideas, thoughts
and solutions: Creating and designing;
Communicating

Three-colour paint job

Age range: 5-11

Individual activity

In this activity the children paint a picture using just the three primary colours. Challenge older or more able children to paint more complex pictures and to use the three colours to create interesting effects.

Materials

- large white painting paper
- red, yellow and blue tempera paint
- brushes in a variety of sizes
- painting challenges written on note cards

Steps to follow

1 Write out the painting challenges below on a piece of card.

2. Invite the children to choose a challenge and use the three primary colours to paint it.

3. Discuss the effect of using the three primary colours together.

Painting challenges

- Paint a beach ball rolling into the sea.
- Paint a rowing boat on the lake on a sunny day.
- Paint red, blue and yellow fruit.
- Paint an aeroplane zooming over a circus tent.
- Paint a watering can in a flower garden.
- Paint a child with an umbrella walking in the rain.
- Paint a child in front of a car.

National Curriculum: Art & design
KS1: 1a, 1b, 2a, 2c, 3a, 4a, 4b, 5b, 5c
KS2: 1a, 1b, 2a, 2b, 2c, 3a, 4a, 4b, 5b, 5c

QCA Schemes: Art & design
Unit 1B – Investigating materials
Unit 2B – Mother Nature, designer
Unit 3B – Investigating pattern
Unit 5A – Objects and meanings

Scottish 5-14 Guidelines: Art & design
Using materials, techniques, skills and media:
Using visual elements – colours
Expressing feelings, ideas, thoughts and solutions: Creating and designing; Communicating

Design a flag
Age range: 5-11
Individual activity

In this activity, the children are asked to create designs for flags using only the three primary colours of red, yellow and blue. Encourage them to experiment with different designs and shapes. You could use the finished flags as folder covers or to decorate the classroom.

Steps to follow

1. Ask the children to plan and design flags using the three primary colours. They may cut the three primary-coloured squares into any shape.

2. Encourage them to experiment and try several different designs before glueing the pieces in place.

3. The children may wish to add details with the black crayon.

Materials

(for each child)

- 23 x 30.5 cm white card
- 15 cm square red card
- 15 cm square blue card
- 15 cm square yellow card
- glue
- scissors
- black crayon (optional)

National Curriculum: Art & design
KS1: 1b, 2a, 2b, 2c, 3a, 4a, 4b, 5b, 5c
KS2: 1b, 2a, 2c, 3a, 4a, 4b, 5b, 5c
QCA Schemes: Art & design
Unit 1B – Investigating materials
Unit 3B – Investigating pattern
Scottish 5-14 Guidelines: Art & design
Using materials, techniques, skills and media:
Using media; Using visual elements – colour
Expressing feelings, ideas, thoughts
and solutions: Creating and designing;
Communicating

Secondary colours

Age range: 5-11

Class or large-group activity

The three primary colours can be mixed to create another set of colours called the secondary colours. The secondary colours are orange, green and purple. This activity investigates how these colours are produced.

Materials

- food colouring and water, premixed in glass jars for the three primary colours – red, blue, and yellow
- small glass bowls or plastic glasses
- three eyedroppers
- overhead projector
- a copy of photocopiable page 29 for each child
- coloured pencils or crayons

National Curriculum: Art & design
KS1: 3a, 4a, 4b, 5b, 5c
KS2: 3a, 4a, 4b, 5b, 5c

Scottish 5-14 Guidelines: Art & design
Using materials, techniques, skills and media:
Using visual elements – colour
Expressing feelings, ideas, thoughts and solutions: Creating and designing; Communicating

Steps to follow

1. Place the three small jars of primary colours on the overhead projector in the positions shown on the colour wheel sheet. Place three empty jars in the positions of the secondary colours.

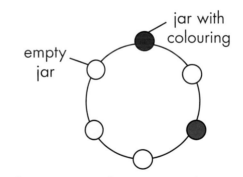

2. Use an eyedropper to mix the primary colours, creating secondary colours in the empty jars. Stir to mix. Always begin with the lighter colour and add the darker colour one drop at a time.

3. When all the mixing is complete, you will have created the three secondary colours – purple, orange, and green.

4. Ask the children to use coloured pencils or crayons and the colour wheel sheet to show how the secondary colours are made.

Note: In this book the word purple is used instead of violet as it is the word commonly used on classroom crayons and paint.

Photocopy this sheet for children to use with Secondary colours on page 28, Mixing and cool colours on page 36 and Complementary turn about on page 41.

SCHOLASTIC
PHOTOCOPIABLE

Name _____

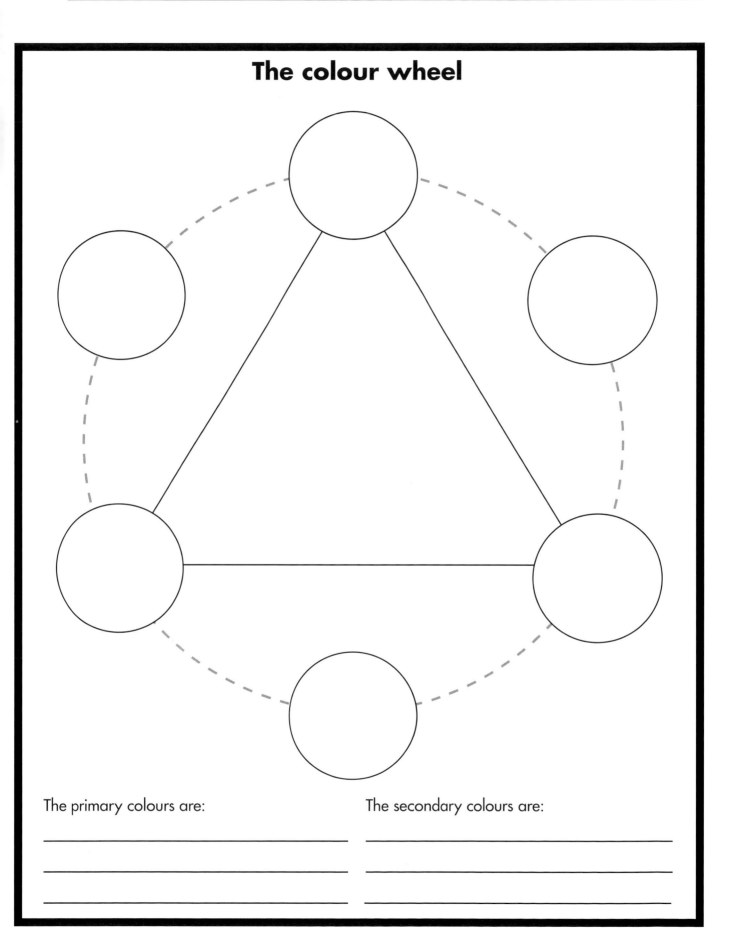

The colour wheel

The primary colours are:

The secondary colours are:

Mixing gradations of colour

Age range: 5-11

Individual activity

This activity allows children to discover that mixing different amounts of a colour changes the colour's hue. As an extension, the children may enjoy creating a design using the coloured squares from the sheet. The squares may be cut out and arranged in interesting designs on another sheet of paper.

Materials

- tempera or watercolour paint
- brushes
- plate or foam tray for mixing colours
- water and paper towels
- a copy of photocopiable page 31 for each child

Steps to follow

1. Ask the children to paint the first square on the sheet and make a dab of the same colour on the plate.

2. Ask the children to follows the directions on the sheet to fill in each square with paint.

4. Let the sheets dry completely.

National Curriculum: Art & design
KS1: 3a, 4a, 4b, 5b, 5c
KS2: 3a, 4a, 4b, 5b, 5c

Scottish 5-14 Guidelines: Art & design
Using materials, techniques, skills and media:
Using visual elements – colour
Expressing feelings, ideas, thoughts and solutions: Creating and designing; Communicating

Photocopy this sheet for children to use with Mixing gradations of colour on page 30.

Name _____

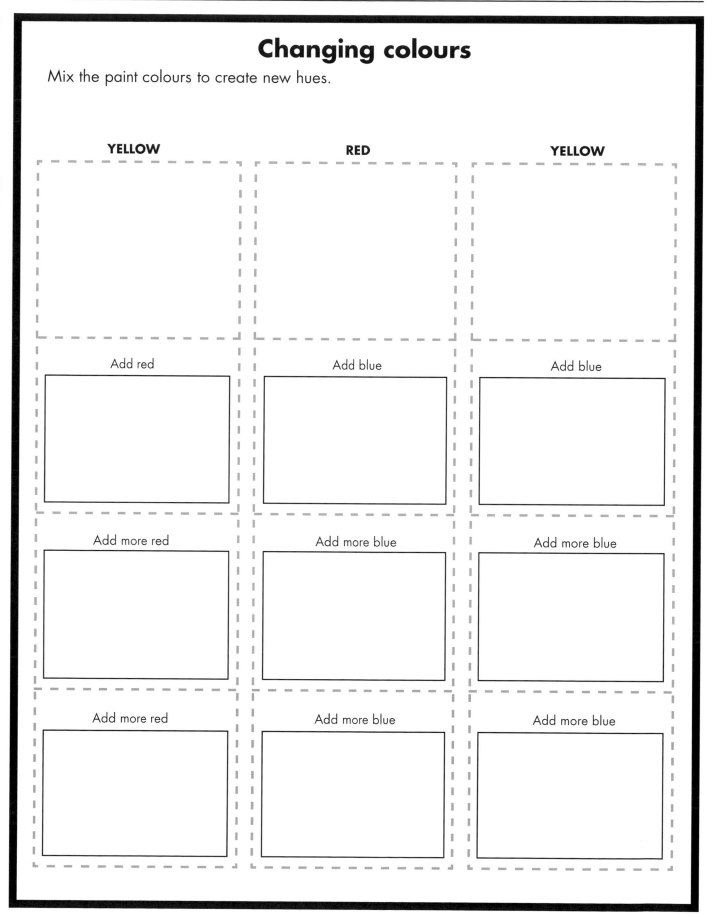

Changing colours

Mix the paint colours to create new hues.

YELLOW	RED	YELLOW
Add red	Add blue	Add blue
Add more red	Add more blue	Add more blue
Add more red	Add more blue	Add more blue

The background makes a difference

Age range: 5-11
Individual activity

This activity looks at contrast. Contrast is the degree of difference between colours or tones. To consolidate the activity, put up a display to encourage class discussion. Use squares of different-coloured sugar paper as the background. Mount the same object on all the squares.

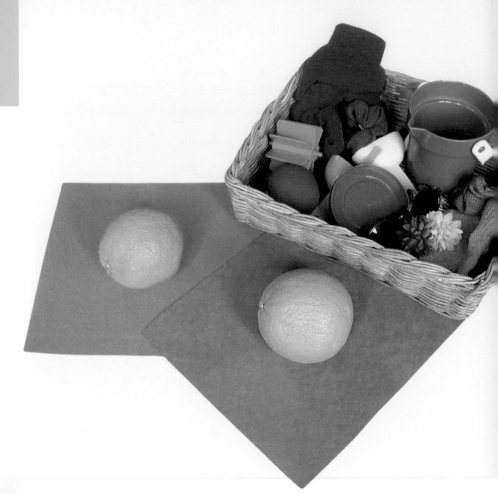

Materials

- a basket of small colourful objects
- 30.5 x 46 cm sheets of coloured card

Steps to follow

1. Invite the children to choose an item and lay it on a coloured background.

2. Then ask them to change the background to see if one colour presents the item in a better way. Which combinations of colour have the best contrast?

3. Ask the children what their favourite background colour is and why they chose it.

National Curriculum: Art & design
KS1: 2a, 2b, 2c, 3a, 4a, 4b, 5b, 5c
KS2: 2a, 2b, 2c, 3a, 4a, 4b, 5b, 5c

QCA Schemes: Art & design
Unit 2B – Mother Nature, designer
Unit 5A – Objects and meanings

Scottish 5-14 Guidelines: Art & design
Using materials, techniques, skills and media:
Using media; Using visual elements – colour
Expressing feelings, ideas, thoughts
and solutions: Creating and designing;
Communicating

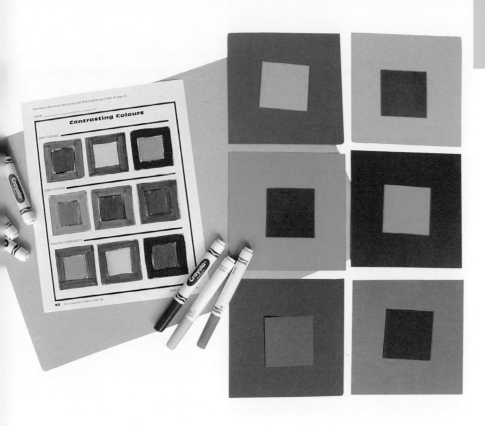

Pick contrasting colours

Age range: 5-11
Individual activity

In this activity, the children have to move the colours around to discover which colours make good contrasts. Older children can investigate how many design combinations they can create. Extend the activity by using different shapes such as triangles and circles.

Steps to follow

1. Ask the children to begin by laying out all six of the larger squares.

2. They should then place one of the smaller squares in the centre of each larger one.

3. Encourage the children to keep rearranging the smaller squares until they find the three best contrasting combinations.

4. Ask the children to use their crayons to record the best combinations on their sheets.

5. Next, ask the children to decide which three combinations of colours represent samples of least contrast. They should experiment with different arrangements and then record their choices on the sheets.

6. Finally, ask the children to record their favourite combinations.

7. Share the class's results. Did the children all choose the same combinations? Are there combinations of colours that are not contrasting but are still pleasing to the eye?

Materials

(for each child)

- 13 cm squares of red, orange, yellow, green, blue and purple card

- six 5 cm squares of card in the same colours

- a copy of photocopiable page 34 for each child

- crayons

National Curriculum: Art & design
KS1: 2a, 2c, 3a, 4a, 4b, 5b, 5c
KS2: 2a, 2c, 3a, 4a, 4b, 5b, 5c
QCA Schemes: Art & design
Unit 1B – Investigating Materials
Scottish 5-14 Guidelines: Art & design
Using materials, techniques, skills and media:
Using media; Using visual elements – colour
Expressing feelings, ideas, thoughts
and solutions: Creating and designing;
Communicating

Name

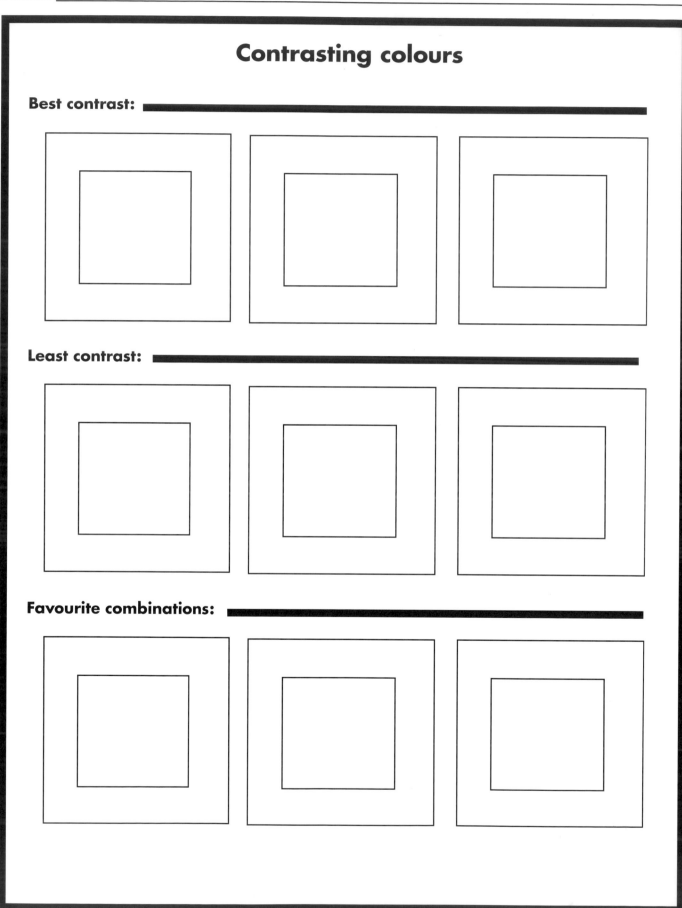

Contrasting colours

Best contrast:

Least contrast:

Favourite combinations:

Colourful collage

Age range: 5-11
Small-group activity

Blue, green and purple are often called cool colours. Yellow, orange, and red are called warm colours. In this activity the children explore the effects of cool and warm colours by creating a collage.

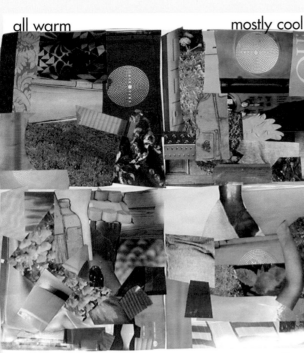

all warm mostly cool

mostly warm all cool

Steps to follow

1. Divide the class into small groups.

2. Ask each group to fold their paper square into quarters and to label the sections of the paper: all warm, all cool, mostly warm (with a cool accent), mostly cool (with a warm accent).

3. Let the children search through magazines to find patches of colour that fit one of the categories. Samples may be torn or cut from the magazines and glued in the correct section.

4. When all the groups have finished, it is interesting to compare the final effects. The group papers could be cut into separate sections and framed as a display in the classroom.

Materials

(for each group)

- magazines
- 91.5 cm square of white paper
- scissors
- glue

National Curriculum: Art & design
KS1: 2a, 2b, 2c, 3a, 4a, 4b, 5b, 5c
KS2: 2a, 2c, 3a, 4a, 4b, 5b, 5c
QCA Schemes: Art & design
Unit 1B – Investigating materials
Unit 4A – Viewpoints
Scottish 5-14 Guidelines: Art & design
Using materials, techniques, skills and media:
Using media; Using visual elements – colour
Expressing feelings, ideas, thoughts
and solutions: Creating and designing;
Communicating

Mixing warm and cool colours

Age range: 5-11

Individual activity

In this activity the children experiment with mixing the primary and secondary colours to produce different hues of warm and cool colours. Encourage the children to keep the primary colours on one tray and mix the colours on a separate tray.

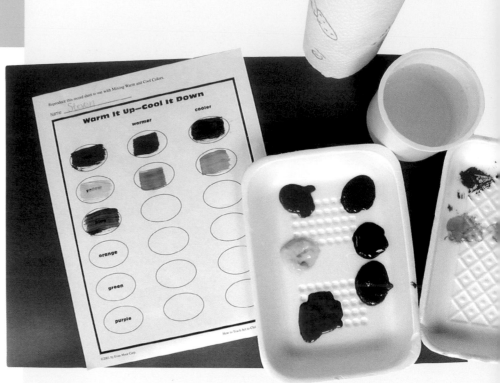

Materials

(for each child)

- tempera paint in red, yellow, blue, orange, green and purple
- brush
- water
- plates or foam trays for mixing colours
- a copy of photocopiable page 37

National Curriculum: Art & design
KS1: 3a, 4a, 4b, 5b, 5c
KS2: 3a, 4a, 4b, 5b, 5c
QCA Schemes: Art & design
Unit 4A – Viewpoints
Scottish 5-14 Guidelines: Art & design
Using materials, techniques, skills and media:
Using visual elements – colour
Expressing feelings, ideas, thoughts
and solutions: Creating and designing;
Communicating

Steps to follow

1. Ask the children to begin by painting the spot on the sheet with red paint.

2. Ask them to add a warm primary colour to red to make a warmer red, and paint the warm red spot on the sheet.

3. The children should then add a cool primary colour to red to make a cooler red, and paint the cool red spot on the sheet.

4. Ask the children to continue like this for each colour on the colour wheel.

Name _____

Warm it up – cool it down

	warmer	cooler
red		
yellow		
blue		
orange		
green		
purple		

My favourite palette

Age range: 5-11

Individual activity

This activity allows the children to use their knowledge of primary and secondary colour mixing to produce their own artwork. Extend the activity for older children by asking them to paint dream or imaginary pictures.

Materials

- painting paper
- tempera paints
- brushes
- water
- plates for mixing colours

National Curriculum: Art & design
KS1: 1a, 2a, 2b, 2c, 3a, 4a, 4b, 5b, 5c
KS2: 1a, 1c, 2a, 2b, 2c, 3a, 4a, 4b, 5b, 5c

QCA Schemes: Art & design
Unit 4A – Viewpoints

Scottish 5-14 Guidelines: Art & design
Using materials, techniques, skills and media:
Using visual elements – colour
Expressing feelings, ideas, thoughts and solutions: Creating and designing;
Communicating

Steps to follow

1. Write the information in the yellow box below on a card.

2. Ask the children to select a palette from the card and to paint a picture using their chosen palette.

3. Ask them to write an explanation of why they chose the palette they did.

4. Display the children's artwork and written explanations.

Pick a palette

Paint a picture with the palette you like the best.
- Warm colours only
- Cool colours only
- Warm colours with a cool accent
- Cool colours with a warm accent

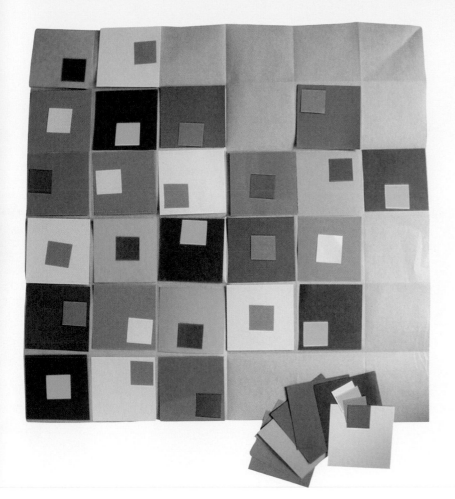

Complementary colours

Age range: 5-11
Large-group activity

This activity introduces and explores the use of complementary colours in artwork. Complementary colours are pairs of colours that sit opposite one another on the colour wheel.

Steps to follow

1. Fold the paper square into 15 cm squares to form a grid. Open it up and press it flat. Pin it to a display board.

2. Give each child a 15 cm square and a 5 cm square of the coloured card in complementary colours.

3. Invite the children to take turns to pin up the large coloured squares onto the paper grid. They may choose any available position for their squares.

4. Then ask the children to take turns to pin up their small squares onto a large square of a complementary colour. Small squares may be positioned anywhere within the larger squares, for example in the centre or in a corner.

Materials

- 91.5 cm square of paper

- 15 cm squares of card – six each of red, orange, yellow, green, blue and purple

- 5 cm squares of card – six each of red, orange, yellow, green, blue and purple

- straight pins

National Curriculum: Art & design
KS1; 3a, 4a, 4b, 5b, 5c
KS2: 3a, 4a, 4b, 5b, 5c
Scottish 5-14 Guidelines: Art & design
Using materials, techniques, skills and media:
Using visual elements – colour
Expressing feelings, ideas, thoughts
and solutions: Creating and designing;
Communicating

Complementary rip and paste

Age range: 5-11

Individual activity

In this activity, the children will need to be able to identify complementary colours as they create an abstract design. After the designs are completed you could laminate them. The designs could be used as a book cover or a card.

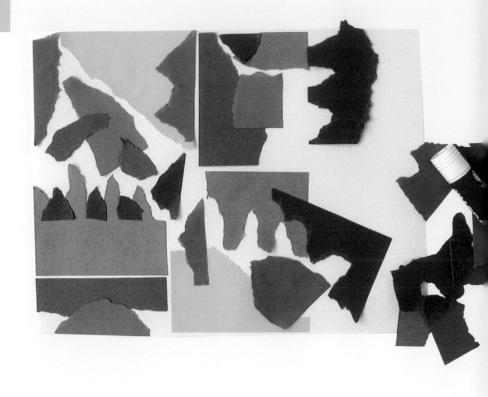

Materials

(for each child)

- 23 x 30.5 cm white card
- 10 cm squares of card in red, orange, yellow, green, blue and purple
- glue

Steps to follow

1. Explain that this project has one rule – only complementary colours may touch each other.

2. Ask the children to rip off a piece of each coloured square.

3. Challenge the children to lay all the pieces on the white card in a random design, remembering the rule.

4. Ask the children to add additional ripped pieces to create a pleasing design.

5. When they are happy with the result, ask the children to glue the pieces in place.

National Curriculum: Art & design
KS1: 2a, 2b, 2c, 3a, 4a, 4b, 5b, 5c
KS2: 2a, 2b, 2c, 3a, 4a, 4b, 5b, 5c

QCA Schemes: Art & design
Unit 1B – Investigating materials
Unit 3B – Investigating pattern

Scottish 5-14 Guidelines: Art & design
Using materials, techniques, skills and media:
Using media; Using visual elements – colour
Expressing feelings, ideas, thoughts
and solutions: Creating and designing;
Communicating

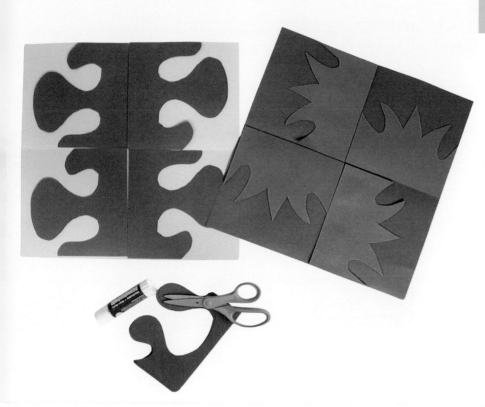

Complementary turn about

Age range: 7-11
Individual activity

This cut-and-paste activity results in a striking design. It could be used as a fun maths activity to support work on rotation, symmetry and pattern. The designs could also be used as covers for work folders.

Steps to follow

1. Invite the children to choose a large square and four small squares of a complementary colour.

2. Ask the children to draw an interesting line across one of the small squares.

3. Holding the four small squares together, ask the children to cut along the line.

4. The children should then fold the large square into quarters and open it up.

5. Ask them to glue one of the cut pieces in each section of the larger square. The result is a design that demonstrates a striking use of complementary colours and a simple repetitive design.

Materials

(for each child)

- four 15 cm squares of coloured card (provide a choice of all the colours on the colour wheel)
- 30.5 cm square of coloured card (provide a choice of all the colours on the colour wheel)
- pencil or marker pen
- glue
- scissors

National Curriculum: Art & design
KS1: 1a, 2a, 2b, 2c, 3a, 4a, 4b, 5b, 5c
KS2: 1a, 2a, 2b, 2c, 3a, 4a, 4b, 5b, 5c

QCA Schemes: Art & design
Unit 1B – Investigating materials
Unit 3B – Investigating pattern

Scottish 5-14 Guidelines: Art & design
Using materials, techniques, skills and media:
Using media; Using visual elements – colour
Expressing feelings, ideas, thoughts
and solutions: Creating and designing;
Communicating

Tertiary colours

Age range: 5-11

Large-group activity

This activity introduces the tertiary colours used in art. Tertiary colours are colours created by mixing secondary colours. Mixing these hues tends to create colours with a greyish or muted effect.

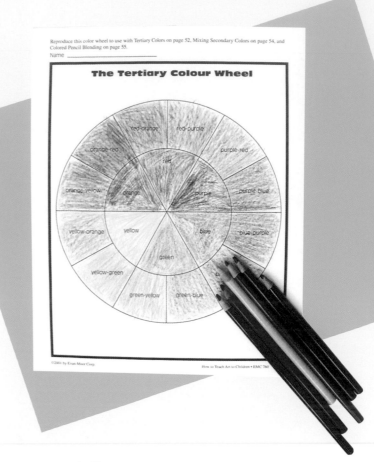

Reproduce this color wheel to use with Tertiary Colors on page 52, Mixing Secondary Colors on page 54, and Colored Pencil Blending on page 55.

Name _____

The Tertiary Colour Wheel

©2001 by Evan-Moor Corp. How to Teach Art to Children • EMC 760

Materials

(for each child)

- a copy of photocopiable page 43
- coloured pencils or crayons in the six colours on the colour wheel
- clipboards
- pencils

Steps to follow

1. Ask the children to colour in the photocopiable sheet. They should blend the colours of the basic colour wheel to make the tertiary colours.

2. Take the class on a walk around the playground or neighbourhood. Help the children to identify tertiary colours in their environment. Ask each child to list two examples by each colour.

grey-green

yellow-green

blue-green

National Curriculum: Art & design
KS1: 3a, 4a, 4b, 5b, 5c
KS2: 3a, 4a, 4b, 5b, 5c

Scottish 5-14 Guidelines: Art & design
Using materials, techniques, skills and media:
Using visual elements – colour
Expressing feelings, ideas, thoughts and solutions: Creating and designing; Communicating

Photocopy this colour wheel for children to use with Tertiary colours on page 42 and Mixing to match on page 44.

Name _____

The tertiary colour wheel

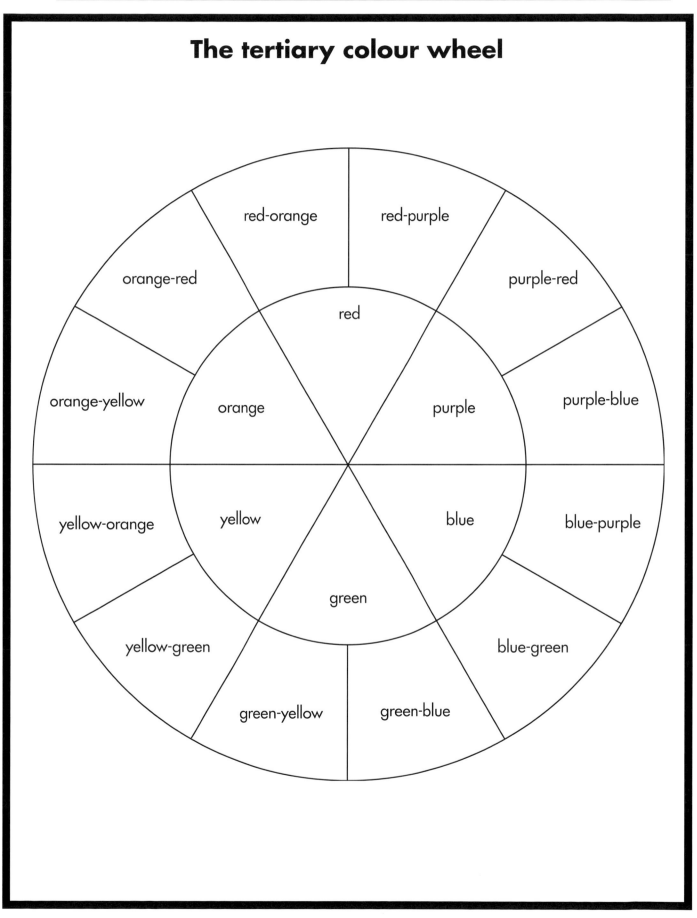

Mixing to match

Age range: 5-11
Small-group activity

In this activity, the children mix secondary colours to match the colours they see in nature. They also learn to use skills in observing and representing nature as an art form. Once older children have finished their work, ask them to label their colours. Encourage them to write descriptive sentences about the items using a tertiary colour words as part of the description.

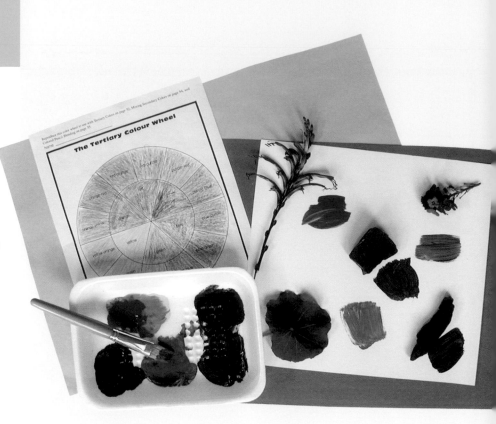

Materials

(for each group)

- tempera paints in red, orange, yellow, green, blue and purple
- white paper
- small items that have muted colours, for example leaves, rocks, flowers, rusted pipes, erasers and wood chips
- plate or tray for mixing colours
- brush
- glue
- a copy of photocopiable page 45 for each child

National Curriculum: Art & design
KS1: 1a, 2a, 2b, 2c, 3a, 4a, 4b, 5a, 5b, 5c
KS2: 1a, 1c, 2a, 2b, 2c, 3a, 4a, 4b, 5a, 5b, 5c
QCA Schemes: Art & design
Unit 2B: Mother Nature, designer
Scottish 5-14 Guidelines: Art & design
Using materials, techniques, skills and media:
Using media; Using visual elements – colour
Expressing feelings, ideas, thoughts
and solutions: Creating and designing;
Communicating

Steps to follow

1. Divide the class into small groups. Ask the children to colour in their tertiary colour wheels if they have not been completed before.

2. Give each group four or five items to use for colour matching.

3. Ask the children to lay each item beside the colours on the wheel to determine which colours are the closest matches.

4. Ask the children to mix the paint until they feel they have reached a good match. They should then paint a sample splotch on the white paper and glue the items next to the mixed colours.

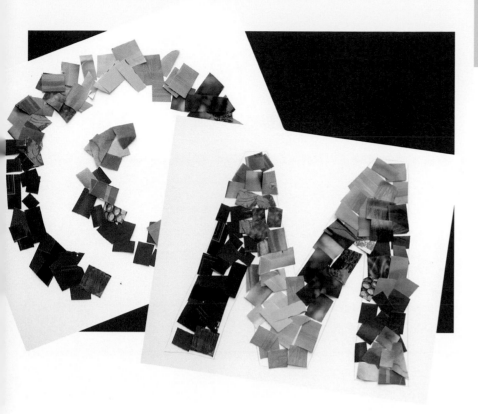

Rainbow of colours

Age range: 5-11
Individual activity

In this activity the children use their knowledge of colour hues to build up colourful mosaic pictures with scraps of paper cut from magazines. Older or more able children can group coloured squares into a tertiary colour wheel.

Steps to follow

1. Ask the children to cut out small squares of colours from magazines.

2. Challenge them to divide the colours into warm-colour and cool-colour piles. Then should then separate those piles into more defined piles of secondary and tertiary colours.

3. Once they have at least six piles (red, orange, yellow, green, blue and purple), ask the children to glue the squares into place to form a design or a block letter that has been traced onto white paper.

Materials

- white paper or card
- magazines
- scissors
- glue

National Curriculum: Art & design
KS1: 2a, 2b, 2c, 3a, 4a, 4b, 5b, 5c
KS2: 2a, 2b, 2c, 3a, 4a, 4b, 5b, 5c
QCA Schemes: Art & design
Unit 1B – Investigating materials
Scottish 5-14 Guidelines: Art & design
Using materials, techniques, skills and media:
Using media; Using visual elements – colours
Expressing feelings, ideas, thoughts
and solutions: Creating and designing;
Communicating

TONE

Learning about tone

Tone gives colours a depth or lightness in a piece of art. Any hue or colour on the colour wheel may have an infinite number of tones. When colours are used at full tone, they appear strong and bright. When colours are mixed with white paint or water, they appear as muted, lighter tones. Tones are used in art to create a sense of shape, a mood, shadows and an atmosphere.

In this section on tone, the children develop skills in creating tone by contrasting black with white. They can explore the many different shades of grey by colour-mixing black and white and use the shades to create a picture. They can also begin to learn skills in shading objects with pencils to give the objects a sense of shape and depth. Finally they can learn to mix colours with white to produce lighter, muted shades.

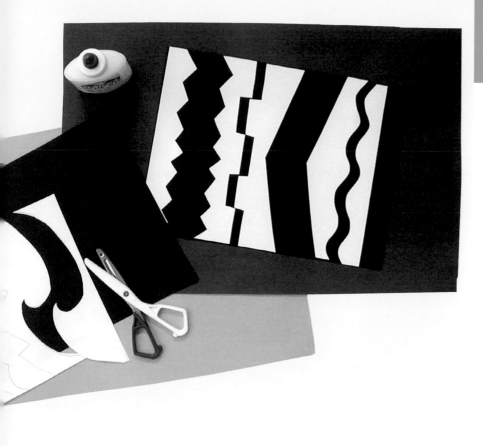

Black and white

Age range: 5-11
Individual activity

Black and white can offer a striking contrast when used together. In this activity the children investigate ways of using black and white to create a strong visual design. Extend the activity by asking the children to look for other designs or objects around them that use just black and white, for example a zebra crossing.

Steps to follow

1. Ask the children to draw several light pencil lines from the top to the bottom of the white paper.
2. They should then cut the white paper on the pencil lines.
3. Ask them to spread out the white strips across the black paper.
4. Encourage them to experiment with variations and then glue the white strips in place.

Materials

(for each child)

- 23 x 30.5 cm black card
- 23 x 15 cm white card
- scissors
- glue
- pencil

National Curriculum: Art & design
KS1: 2a, 2c, 3a, 4a, 4b, 5b, 5c
KS2; 2a, 2c, 3a, 4a, 4b, 5b, 5c

QCA Schemes: Art & design
Unit 1B – Investigating materials
Unit 3B – Investigating pattern

Scottish 5-14 Guidelines: Art & design
Using materials, techniques, skills and media:
Using media; Using visual elements – tone
Expressing feelings, ideas, thoughts
and solutions: Creating and designing;
Communicating

In between

Age range: 7-11
Individual activity

Tones of grey exist between black and white. This activity involves the creation of a light to dark scale and requires careful colour mixing. After the activity, discuss the different names the children used to describe their final shades.

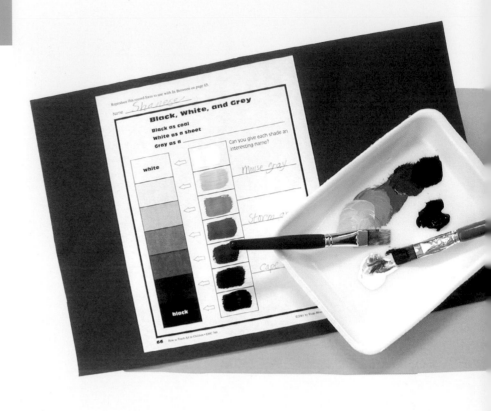

Materials

(for each child)

- white and black tempera paint
- paintbrush
- water for cleaning the brush
- paper towels
- plate or foam tray for mixing colours
- a copy of photocopiable page 49

Steps to follow

1. Ask the children to paint the white and black boxes on the photocopiable page.

2. Ask them to mix the middle tone. They should begin by putting white on their plates and slowly adding drops of black until they create the grey that they feel should be in the middle.

3. After painting the middle tone, the children should mix gradations of grey and fill in the other four boxes.

4. Challenge the children to give each in-between colour a new name.

National Curriculum: Art & design
KS1: 3a, 4a, 4b, 5b, 5c
KS2: 3a, 4a, 4b, 5b, 5c
Scottish 5-14 Guidelines: Art & design
Using materials, techniques, skills and media:
Using visual elements – tone
Expressing feelings, ideas, thoughts
and solutions: Creating and designing;
Communicating

Name _____

Black, white and grey

Black as coal

White as a sheet

Grey as a _____

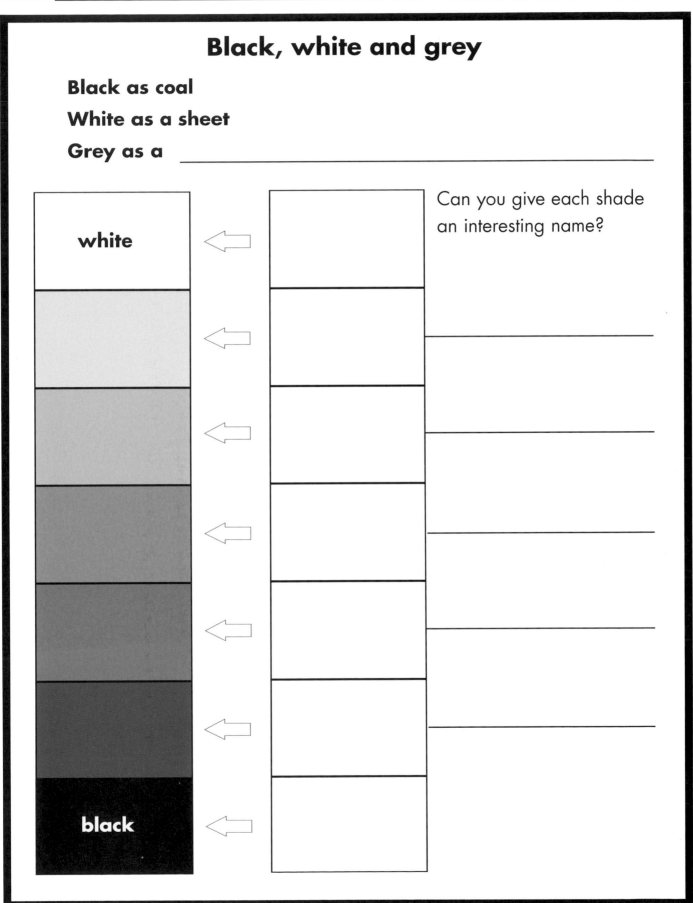

white

black

Can you give each shade an interesting name?

Greys all around

Age range: 5-11

Individual activity

In this activity, the children can experiment with black, white and grey paint by producing paintings that only use these three colours. Encourage them to think of the different effects and shades they could create using black, white and grey.

Paint a cat on a foggy day.

Paint an airplane in a cloud.

Materials

- black and white tempera paint
- plate for mixing paint
- paintbrush
- white easel paper

Steps to follow

1. Challenge the children to think of an object or scene that could be grey or ask them to choose one of the painting challenges below.

2. Ask the children to mix black and white to make various shades of grey.

3. Ask them to complete their pictures using only black, white and grey.

Painting challenges

- Snowman in a snowstorm
- Cat on a foggy day
- Cityscape at night
- Train in a tunnel
- Aeroplane in a cloud

National Curriculum: Art & design
KS1: 2a, 2b, 2c, 4a, 4b, 5b, 5c
KS2: 2a, 2b, 2c, 4a, 4b, 5b, 5c

QCA Schemes: Art & design
Unit 4A – Viewpoints

Scottish 5-14 Guidelines: Art & design
Using materials, techniques, skills and media:
Using visual elements – tone
Expressing feelings, ideas, thoughts
and solutions: Creating and designing;
Communicating

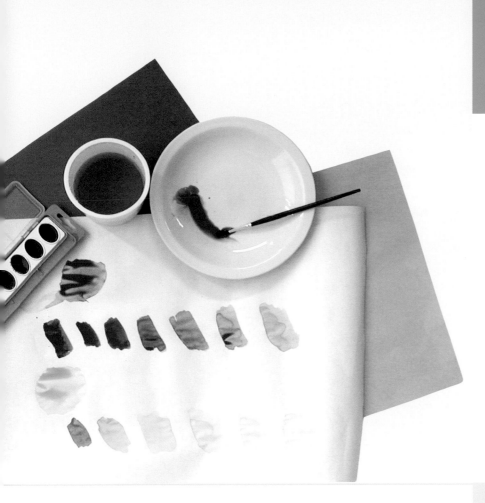

Colours have many tones

Age range: 5-11
Individual activity

In this activity, the children experiment with watercolour paint to discover the different tones they can make by muting the colour with water. As an extension, ask the children to compare the colour to an emotion. A strong emotion like anger can be diluted to a muted emotion like irritation.

Steps to follow

1. Ask the children to create a coloured puddle on their mixing plate using a full-strength primary colour then to paint a blotch of that colour on the white paper.

2. Ask them to create a muted tone of the first shade by adding a brushful of water. They should then paint a sample of that tone on the white paper.

3. Ask them to keep adding water and making blotches until the colour ranges from a strong, pure tone to a muted, pale tone.

4. The children should then repeat the steps, using a different colour.

Materials

(for each child)

- tray of watercolour paints
- large watercolour brush
- large sheet of paper
- plate or dish
- cup of water

National Curriculum: Art & design
KS1: 3a, 4a, 4b, 5b, 5c
KS2: 3a, 4a, 4b, 5b, 5c
QCA Schemes: Art & design
Unit 4A – Viewpoints
Scottish 5-14 Guidelines: Art & design
Using materials, techniques, skills and media:
Using visual elements – tone
Expressing feelings, ideas, thoughts
and solutions: Creating and designing;
Communicating

Mixing colours with white

Age range: 5-11
Individual activity

Colours mixed with white are called tints. This activity encourages the children to create tints of the colour wheel colours by gradually adding small drops of white paint.

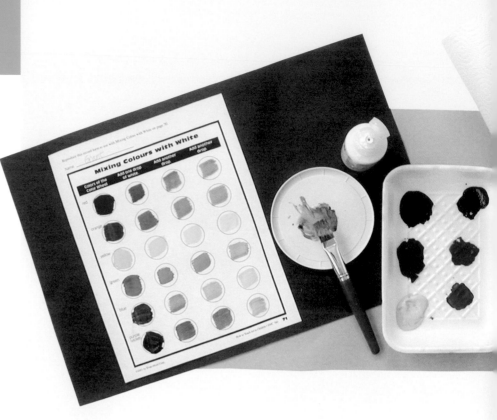

Materials

- tempera paints in red, orange, yellow, green, blue, purple and white
- paintbrush
- plate or foam tray
- access to a sink or washing station
- paper towels
- a copy of photocopiable page 53 for each child

Steps to follow

1. Ask the children to create a small puddle of red paint on the plate and to paint the circle marked 'red' on the sheet.

2. Ask them to add one drop of white paint to the red puddle then to mix this new colour and paint the next circle on the sheet.

3. The children should continue adding single drops of paint for each circle in the row.

4. This procedure should then be followed for the other colours on the colour wheel. Ask the children to wash their plates and brushes before working with a new colour.

National Curriculum: Art & design
KS1: 1a, 2a, 2b, 3a, 4a, 4b, 5b, 5c
KS2: 1a, 2a, 2b, 2c, 3a, 4a, 4b, 5b, 5c

QCA Schemes: Art & design
Unit 1B – Investigating materials

Scottish 5-14 Guidelines: Art & design
Using materials, techniques, skills and media
Using visual elements – tone
Expressing feelings, ideas, thoughts and solutions: Creating and designing; Communicating

Photocopy this sheet for children to use with Mixing colours with white on page 52.

Name _____

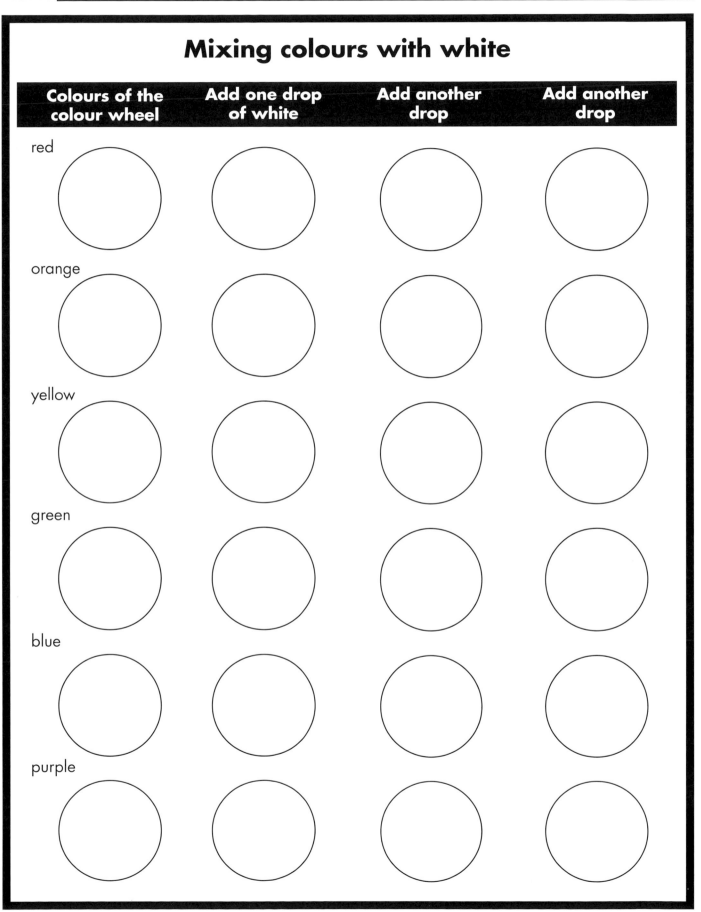

Mixing colours with white

Colours of the colour wheel	Add one drop of white	Add another drop	Add another drop
red			
orange			
yellow			
green			
blue			
purple			

Shading shapes

Age range: 7-11
Class or large-group activity

In this activity, the children will discover that shading adds dimension to shapes. They will also be required to use skills in simple pencil drawing and perspective. Extend the activity for older children by letting them draw and shade an object of their choice.

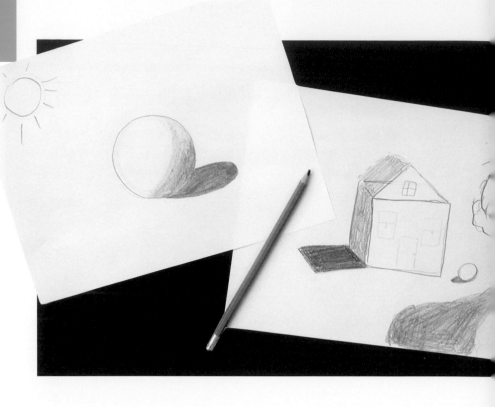

Materials

(for each child)

• paper
• pencils

National Curriculum: Art & design
KS2: 2a, 2b, 2c, 3a, 4a, 4b, 5b, 5c
Scottish 5-14 Guidelines: Art & design
Using materials, techniques, skills and media:
Using visual elements – tone
Expressing feelings, ideas, thoughts
and solutions: Creating and designing;
Communicating

Steps to follow

Direct the children to complete the two drawings below:

Drawing 1

1. Draw a ball.

2. Pretend the sun is in the top left corner of the page. Draw the sun.

3. Shade the right side of the ball.

4. Draw in a shadow on the ground.

Drawing 2

1. Draw a box.

2. Pretend the sun is in the top right corner of the page. Draw the sun.

3. Shade the left side of the box.

4. Draw in a shadow on the ground.

5. Make the box into a house.

6. Add shading to the dark side of the house.

7. Draw a ball or a tree in the yard. Which way will the shadow go?

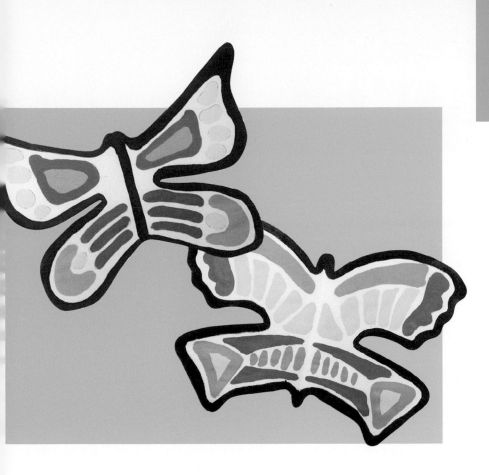

Two butterflies
Age range: 5-11
Individual activity

In this activity the children paint a butterfly by using one colour and white paint. Encourage the children to experiment with contrasting different colours with white paint and discuss which are the most effective.

Steps to follow

1. Ask the children to fold the white card in half and outline with pencil one-half of a butterfly shape. They should then cut on that line.

2. Ask them to open the butterfly shape and use their pencil to lightly sketch a line along the outside border. They should then pencil in various shapes in the centre of the butterfly.

3. Ask the children to use their acrylic paints to paint their butterfly using only one colour of paint mixed with white to create different tones of that colour. Suggest that they use the following method:

 • First paint the outside border with the solid colour. It will have the darkest tone.

 • Then mix that colour with a little white and paint some of the shapes in the centre of the butterfly.

 • Continue adding white to the previous colour and painting until you have a very muted shade of the original colour.

4. Allow the butterflies to dry. Display the children's work so they can appreciate the interesting effects created by using just one colour plus white in a design.

Materials

(for each child)

• 30.5 x 46 cm white card

• acrylic paints in various colours, including white

• brushes in several sizes

• paper plate for mixing paint

• pencil

National Curriculum: Art & design
KS1: 2a, 2b, 2c, 3a, 4a, 4b, 5b, 5c
KS2: 2a, 2b, 2c, 3a, 4a, 4b, 5b, 5c
Scottish 5-14 Guidelines: Art & design
Using materials, techniques, skills and media: Using visual elements – tone
Expressing feelings, ideas, thoughts and solutions: Creating and designing; Communicating

TEXTURE

Learning about texture

The world is full of different textures and children will have first-hand experiences of many textures. They will know about rough rocks, smooth marbles, soft fur and hard, jagged brick walls. Interesting textures make us want to touch and feel and this appeal can be used to bring an added dimension to artwork. Through exploring different textures, children can discover art techniques such as rubbing, tearing, scratching and creasing materials and use these effects in their work. Texture can be used in a range of art forms such as the use of clay and textiles, sculpture, printing, collage and painting.

In this section, children investigate a wide range of textures. They look at textures around them including paper, textiles, paint and sandpaper. They learn to use a range of techniques to make a texture such as scratching, rubbing with crayons, printing with vegetables, tearing, crunching and creasing paper and the use of different textured textiles. Through these activities the children can develop skills to create their own artwork using a chosen texture for added depth and effect.

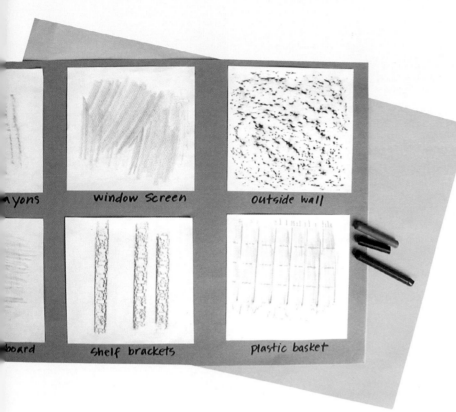

Awareness of texture

Class or large-group activity

This activity introduces the use of textures in artwork. The children will investigate different textures all around them and be encouraged to describe what they see and touch. Let older or more able children categorise their texture rubbings according to the words they listed.

Steps to follow

1. Ask the children to name words that describe how things look and feel. List the words on the board. Sometimes it helps to think in terms of opposites when compiling the list.

 rough grainy

 hard bumpy

 prickly fluffy

2. Ask the children to do rubbings of different textures around the room, using the paper squares.

3. Mount each rubbing on the coloured paper. Label each texture.

Materials

- 13 cm squares of paper
- dark-coloured crayons without paper wrappers
- large piece of coloured paper
- glue

National Curriculum: Art & design
KS1: 1a, 1b, 2a, 2b, 2c, 3a, 4a, 4b, 5a, 5b, 5c
KS2: 1a, 1b, 1c, 2a, 2b, 2c, 3a, 4a, 4b, 5a, 5b, 5c

QCA Schemes: Art & design
Unit 1B – Investigating materials
Unit 2B – Mother Nature, designer
Unit 2C – Can buildings speak?

Scottish 5-14 Guidelines: Art & design
Using materials, techniques, skills and media:
Using media; Using visual elements – texture
Expressing feelings, ideas, thoughts and solutions:
Creating and designing; Communicating

Sharing textures

Age range: 5-11

Small-group activity

In this activity the children work in small groups to collect rubbings of different textured surfaces. They will then create an interesting crayon rubbing by combining textures and colours.

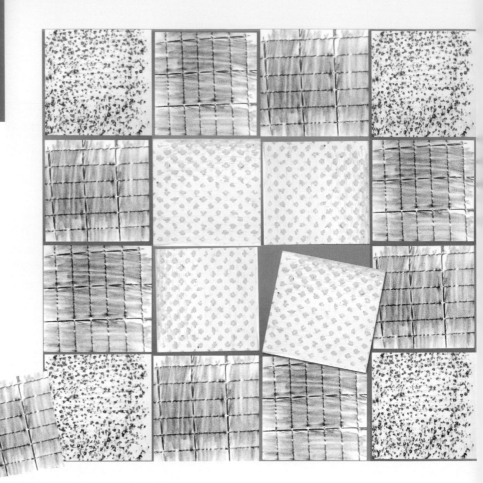

Materials

(for each group)

- 61 cm square of coloured paper
- sixteen 13 cm squares of white card
- crayons without paper wrappers
- glue
- a copy of photocopiable page 59
- surfaces with interesting textures

Steps to follow

1. Divide the class into small groups.

2. Ask the children to plan the colour palette for their texture rubbings in their groups. They should record their decisions on their sheet.

3. Ask them to do the rubbings using the following method:
 - Locate a textured surface.
 - Choose a crayon in the colour palette the group has chosen.
 - Make a rubbing on one of the small squares.

4. Ask the children to fold the coloured paper square into 16 squares.

5. They should then arrange the textures on the paper, placing one rubbing in each square. When they are happy with the arrangement, they can glue the rubbings in place.

National Curriculum: Art & design
KS1: 1a, 1b, 2a, 2b, 4a, 4b, 5a, 5b, 5c
KS2: 1a, 1b, 1c, 2a, 2b, 4a, 4b, 5a, 5b, 5c

QCA Schemes: Art & design
Unit 1B – Investigating Materials
Unit 2B – Mother Nature, designer
Unit 2C – Can buildings speak?

Scottish 5-14 Guidelines: Art & design
Using materials, techniques, skills and media
Using media; Using visual elements – texture
Expressing feelings, ideas, thoughts
and solutions: Creating and designing;
Communicating

Photocopy this sheet for children to use with Sharing textures on page 58.

■ SCHOLASTIC
PHOTOCOPIABLE

Name _____

Plan a group rubbing

Colour palette

Primary colours

Secondary colours

Complementary colours

Cool

Warm

Other

Textures

Now make your rubbings. Experiment with different patterns. Then glue the squares in place in the pattern you like best.

Shape rubbings

Age range: 5-11

Individual activity

In this activity the children experiment with colour and textures to create a rubbing using a single shape. This activity can be extended by having a different texture for each shape rubbing. Discuss the effect of the different colour hues in each design.

Materials

(for each child)

- 30.5 x 46 cm white card
- crayons
- pencil
- black crayon or felt-tip pen

Steps to follow

1. Ask the children to do simple pencil drawings of several houses along a street. The houses should have areas large enough for the children to do rubbings inside the lines.

2. Let the children choose textures and do crayon rubbings to fill the inside area of each building.

3. Ask them to outline the buildings and add details with black crayon or felt-tip pen.

National Curriculum: Art & design
KS1: 2a, 2b, 2c, 3a, 4a, 4b, 5a, 5b, 5c
KS2: 2a, 2b, 2c, 3a, 4a, 4b, 5a, 5b, 5c

QCA Schemes: Art & design
Unit 1B – Investigating materials

Scottish 5-14 Guidelines: Art & design
Using materials, techniques, skills and media:
Using media; Using visual elements – texture
Expressing feelings, ideas, thoughts
and solutions: Creating and designing;
Communicating

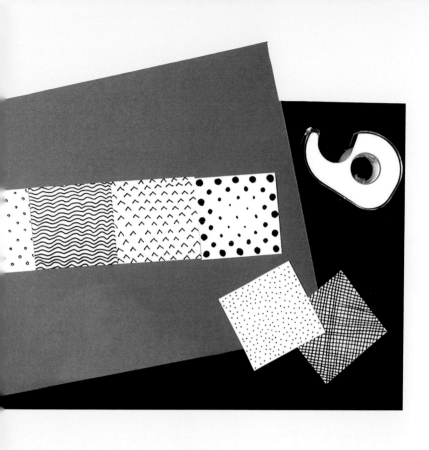

Repetition creates texture

Age range: 5-11

Class or large-group activity

Texture can be created in pictures by using repetition of lines and shapes. In this activity the repetition creates a rhythm that holds the pattern together. This activity could also be used as part of a maths session on pattern.

Steps to follow

1. Discuss with the children how different textures can be created by repeating a pattern. (You will need to show an example for each statement.)

 • One shape repeated over and over fills an area and creates a patterned effect.

 • Wavy lines drawn close together create movement and texture.

 • Cross-hatching adds shading and texture.

 • The distance between squiggles causes a change in the texture created.

 • Stippling (making tiny dots) can create texture.

 • Lines can be repeated in many variations. Lines and shapes repeated close together create a dark effect. Lines and shapes repeated farther apart create a lighter effect.

2. Give each child a 7.5 cm square of white card. Ask them to use a black crayon to create a textured effect with a repeated line or shape.

3. Lay all of the squares in a line and tape them together with transparent tape.

4. Display the line of squares and discuss the different textures created.

Materials

• 7.5 cm squares of white card

• black crayons

• transparent tape

National Curriculum: Art & design
KS1: 2a, 2b, 2c, 3a, 4a, 4b, 5b, 5c
KS2: 2a, 2b, 2c, 3a, 4a, 4b, 5b, 5c
Scottish 5-14 Guidelines: Art & design
Using materials, techniques, skills and media:
Using visual elements – texture
Expressing feelings, ideas, thoughts
and solutions: Creating and designing;
Communicating

Creating texture with paint

Age range: 5-11

Individual activity

In this activity, the children experiment with a range of painting techniques to create different textures. Encourage the children to explore other ways of making textures. Patting, dragging, and scribbling with the finger or the fingernail is very effective.

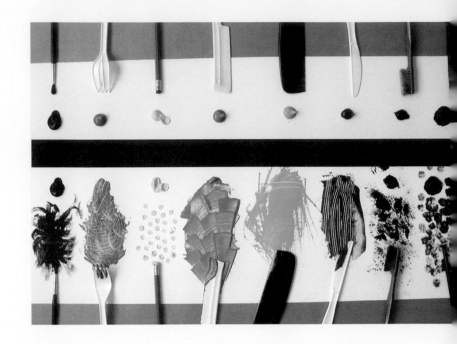

Materials

- easel paper
- tempera paints
- several different-sized brushes
- assorted objects to use in creating textures: toothbrush, pencil, comb, plastic utensils, fingers
- display board

National Curriculum: Art & design
KS1: 2a, 2b, 2c, 3a, 4a, 4b, 5b, 5c
KS2: 2a, 2b, 2c, 3a, 4a, 4b, 5b, 5c

Scottish 5-14 Guidelines: Art & design
Using materials, techniques, skills and media:
Using media; Using visual elements – texture
Expressing feelings, ideas, thoughts and solutions: Creating and designing; Communicating

Steps to follow

1. Demonstrate some of the techniques that create texture in a painting, for example:
 dry brush
 thick brush vs. narrow brush
 splatter
 fingers
 stipple
 wavy
 toothbrush rubbed across screen
 overlaying or mixing colours.

2. Show labelled examples of the techniques on the display board.

3. Encourage the children to experiment with different effects, adding new ones to the display board as they discover them.

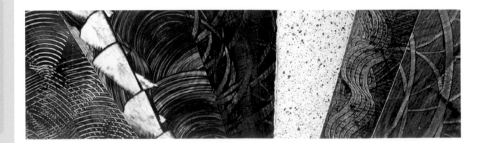

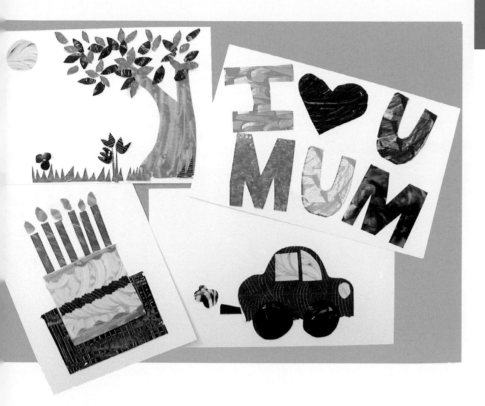

Textured paint collage

Age range: 5-11
Individual activity

In this activity, the children cut apart textured paint papers they have created and make new simple collage pictures. Encourage older children to use this technique to make effective greeting cards or covers for a topic or project book.

Steps to follow

1. Squeeze a small amount of paint onto each 10 cm square of card.

2. Let the children experiment with creating different textures on each of their coloured squares.

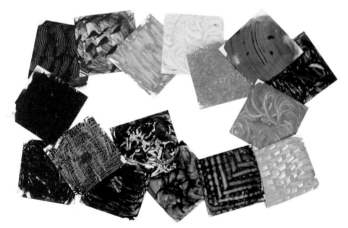

3. Let the painted squares dry completely.

4. Brainstorm simple picture or design ideas that could be cut from the squares.

5. Glue the shapes to the white card.

Materials

(for each child)

- 10 x 15 cm white card
- three 10 cm squares of white card
- acrylic paints
- flat-ended paintbrush
- scraps of cardboard
- plastic fork, plastic knife, comb (any object that will help to create a texture)
- scissors
- glue

National Curriculum: Art & design
KS1: 1a, 2a, 2b, 2c, 3a, 4a, 4b, 5b, 5c
KS2: 1a, 2a, 2b, 2c, 3a, 4a, 4b, 5b, 5c

QCA Schemes: Art & design
Unit 1B – Investigating materials
Unit 5C – Talking textiles

Scottish 5-14 Guidelines: Art & design
Using materials, techniques, skills and media:
Using media; Using visual elements – texture
Expressing feelings, ideas, thoughts
and solutions: Creating and designing;
Communicating

Print a texture

Age range: 5-11

Individual activity

In this activity, the children use simple printing techniques to create a texture and pattern in a picture. Simple objects with different textures can be used as printing blocks such as peppers, sponges and potatoes.

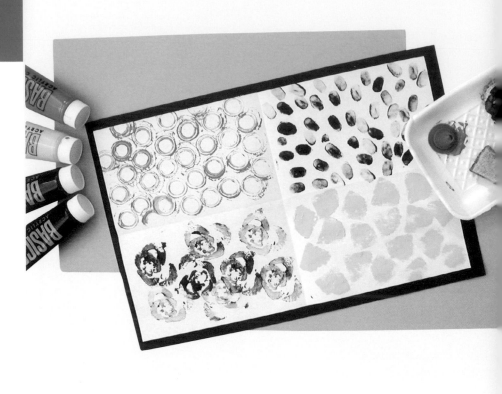

Materials

- 30.5 x 46 cm white card
- tempera paint in several colours
- sponges, potatoes and gadgets
- foam trays or plates

Steps to follow

1. Ask the children to fold their card into quarters.
2. Ask them to make a different print of their choice in each area of the paper.
3. Let the paintings dry and discuss the textured effects created.

How to make a print

1. Pour a puddle of paint onto a flat container.
2. Dip one edge of an object into the paint.
3. Press the painted edge on the paper.
4. Lift the object straight up.
5. Repeat dipping, pressing and lifting.

National Curriculum: Art & design
KS1: 2a, 2b, 2c, 3a, 4a, 4b, 5b, 5c
KS2: 2a, 2b, 2c, 3a, 4a, 4b, 5b, 5c

QCA Schemes: Art & design
Unit 2B – Mother Nature, designer
Unit 3B – Investigating pattern

Scottish 5-14 Guidelines: Art & design
Using materials, techniques, skills and media:
Using media; Using visual elements – texture
Expressing feelings, ideas, thoughts
and solutions: Creating and designing;
Communicating

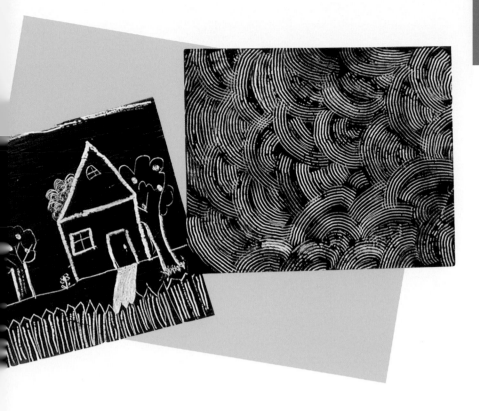

Scratch-away texture

Age range: 5-11
Individual activity

In this activity, the children discover the textured effects of scratchboard painting. They explore a range of tools to make different textured effects on the black paint. As this can be a messy activity, it is recommended that you cover the tables with plastic or newspaper to make the clean-up easier.

Steps to follow

1. Ask the children to fill the white card with colour. The crayon lines should be thick and solid.

2. The children should then paint over the completed crayon design with a mixture of black tempera paint and a few drops of detergent.

3. Let the paint dry completely.

4. Ask the children to use the plastic knife to gently scratch away a design, revealing the colour below.

Materials

(for each child)

- 23 x 30.5 cm white card
- crayons
- black tempera paint
- liquid detergent
- paintbrush
- plastic knife

National Curriculum: Art & design
KS1: 2a, 2b, 2c, 3a, 4a, 4b, 5b, 5c
KS2: 2a, 2b, 2c, 3a, 4a, 4b, 5b, 5c
QCA Schemes: Art & design
Unit 1B – Investigating materials
Scottish 5-14 Guidelines: Art & design
Using materials, techniques, skills and media:
Using media; Using visual elements – texture
Expressing feelings, ideas, thoughts
and solutions: Creating and designing;
Communicating

A collage has a texture

Age range: 5-11

Class or large-group activity

A collage is a composition made by affixing pieces of paper, string, cloth, wallpaper and other materials to a surface. In this activity, the children are shown how to change a range of materials into different textures to make a creative effect.

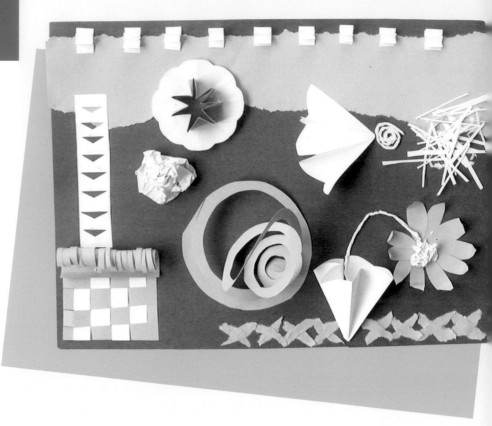

Materials

(for each child)

- two 23 x 30.5 cm pieces of card (one each of two colours)
- sheet of A4 paper
- scissors
- glue

National Curriculum: Art & design
KS1: 2a, 2b, 2c, 3a, 4a, 4b, 5b, 5c
KS2: 2a, 2b, 2c, 3a, 4a, 4b, 5b, 5c

QCA Schemes: Art & design
Unit 1B – Investigating materials
Unit 5C – Talking textiles

Scottish 5-14 Guidelines: Art & design
Using materials, techniques, skills and media: Using media; Using visual elements – texture
Expressing feelings, ideas, thoughts and solutions: Creating and designing; Communicating

Steps to follow

1. Let the children choose a piece of card for a background.

2. Demonstrate several techniques for changing the texture of a collage, for example:

 - tear the paper and leave a torn edge
 - cut the paper
 - crinkle the paper and then smooth it out
 - score the paper and bend it
 - twist the paper
 - pleat the paper
 - weave the paper in and out
 - layer the paper.

3. Challenge the children to use the other piece of card and the paper to create a collage. Encourage them to invent their own techniques to create texture.

4. Glue the pieces of paper to the background.

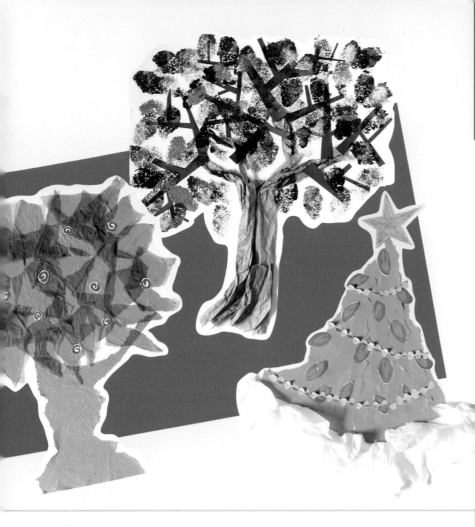

Texture a tree
Age range: 5-11
Small-group activity

In this activity, the children work together in groups to make collages of trees using different techniques to create a range of textures. Before the activity, you may want to take younger children outside to look at different trees and discuss their textures.

Steps to follow

1. Divide the class into groups of two to four children.

2. Explain the objective of the assignment – to create a tree using several different texture techniques. Ask the children to brainstorm different types of trees that they might create, for example:
 - blossoming trees
 - fruit trees
 - evergreen trees with pinecones
 - cactus
 - oak tree with acorns
 - tree with autumn-coloured leaves.

3. Give the groups time to plan their trees and gather the necessary materials. The children will need to assign specific jobs and work together to complete the job.

4. Ask the children to list all the texture techniques used on their trees.

5. Ask them to make and cut out their trees and put them on display.

Materials

(for each group)

- 91.5 cm square of paper
- assorted scraps of card
- assorted craft papers such as paper bags, wallpaper, wrapping paper, tissue
- tempera paint in assorted colours
- brushes, sponges and gadgets
- scissors
- white glue

National Curriculum: Art & design
KS1: 1a, 2a, 2b, 2c, 3a, 4a, 4b, 5a, 5b, 5c
KS2: 1a, 2a, 2b, 2c, 3a, 4a, 4b, 5a, 5b, 5c

QCA Schemes: Art & design
Unit 1B – Investigating materials
Unit 2B – Mother Nature, designer

Scottish 5-14 Guidelines: Art & design
Using materials, techniques, skills and media:
Using media; Using visual elements – textures
Expressing feelings, ideas, thoughts and solutions: Creating and designing; Communicating

My personal collage

Age range: 5-11

Individual activity

In this activity, the children have a choice of materials to practise texture techniques. Using these techniques they can create a collage that represents a theme or event. Younger children may need to be given ideas such as a collage for a birthday party or a collage that shows a favourite pet.

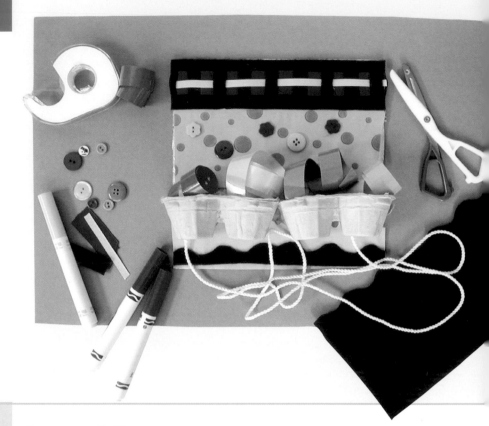

Materials

- 23 cm squares of cardboard
- materials to make a collage for example paper bags, aluminium foil, scraps of wallpaper, scraps of wrapping paper, coloured papers, packaging materials, corrugated paper, wool, cellophane, tissue paper, fabric, egg cartons
- tempera paint
- brushes
- scissors

National Curriculum: Art & design
KS1: 1a, 1b, 2a, 2b, 2c, 3a, 4a, 4b, 5b, 5c
KS2: 1a, 1b, 1c, 2a, 2b, 2c, 3a, 4a, 4b, 5b, 5c

QCA Schemes: Art & design
Unit 1B – Investigating materials
Unit 4A – Viewpoints

Scottish 5-14 Guidelines: Art & design
Using materials, techniques, skills and media: Using media; Using visual elements – texture
Expressing feelings, ideas, thoughts and solutions: Creating and designing; Communicating

Steps to follow

1. Review texture techniques with the children. Remind them that they can tear paper, cut paper, overlap patterns, use paint plus torn paper or use special scissors.

2. Give the children time to plan and make a collage.

3. Ask the children to explain any special texture technique they developed.

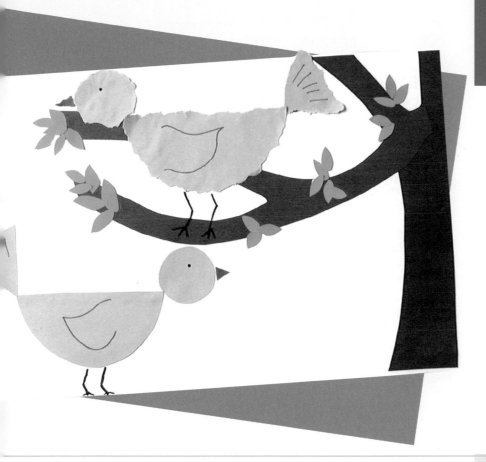

Animal collage

Age range: 5-11
Individual activity

In this activity the children create two animals in a collage. The animals are the same except one is a cut-paper design and the other is a torn-paper design.

Steps to follow

1. Let the children choose an animal for their collage. It is best if they can create their animal drawing out of simple, basic shapes. Ask them to draw the animal on the paper and cut out the animal body parts.

2. Ask the children to trace the animal shapes onto card. Each shape should be traced twice.

3. Children should then cut out one set of shapes and tear out the other set of shapes.

4. Ask the children to lay the shapes on a card background and glue them in place.

5. Finally, ask them to use additional paper pieces to create a background and add details with crayons or felt-tip pens.

Materials

(for each child)

- paper
- 30.5 x 46 cm white card
- scraps of card in assorted sizes and colours
- wallpaper, wrapping paper, paper bags etc.
- crayons and felt-tip pens
- scissors
- white glue

National Curriculum: Art & design
KS1: 1a, 1b, 2a, 2b, 2c, 3a, 4a, 4b, 5a, 5b, 5c
KS2: 1a, 1b, 1c, 2a, 2b, 2c, 3a, 4a, 4b, 5a, 5b, 5c

QCA Schemes: Art & design
Unit 1B – Investigating materials
Unit 3A – Portraying relationships
Unit 4A – Viewpoints

Scottish 5-14 Guidelines: Art & design
Using materials, techniques, skills and media:
Using media; Using visual elements – texture
Expressing feelings, ideas, thoughts and solutions:
Creating and designing; Communicating

Fabric collage
Age range: 5-11
Individual activity

This activity allows children to explore and create varied and interesting collages using different patterns and textures of fabric. Younger children may find some fabric hard to cut with classroom scissors and so you may want to provide pre-cut strips, squares and circles.

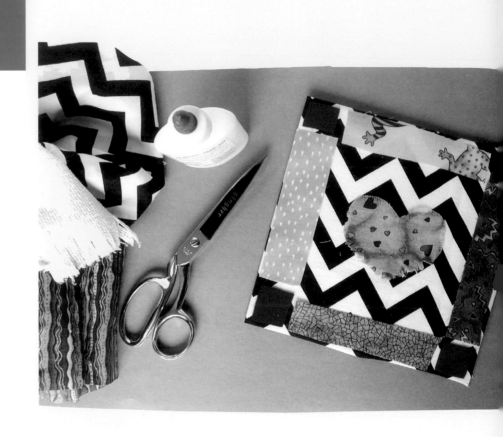

Materials

- scraps of fabric (as many colours, textures, and patterns as possible)
- 20 cm squares of cardboard
- scissors that will cut fabric
- white glue

Steps to follow

1. Set out the materials for the collage.

2. Let the children choose some fabric. They will need to browse through the available selection to choose the combination of pieces they want to use together.

3. Ask the children to experiment with different arrangements. They may want to try tearing the fabric as well as cutting it. Patterns may overlap or weave in and out.

4. When they are happy with their arrangement, ask the children to brush the pieces with diluted white glue and place them on the cardboard.

National Curriculum: Art & design
KS1: 1a, 1b, 2a, 2b, 2c, 3a, 4a, 4b, 5b, 5c
KS2: 1a, 1b, 1c, 2a, 2b, 2c, 3a, 4a, 4b, 5b, 5c

QCA Schemes: Art & design
Unit 1B – Investigating materials
Unit 5C – Talking textures

Scottish 5-14 Guidelines: Art & design
Using materials, techniques, skills and media:
Using media; Using visual elements – texture
Expressing feelings, ideas, thoughts
and solutions: Creating and designing;
Communicating

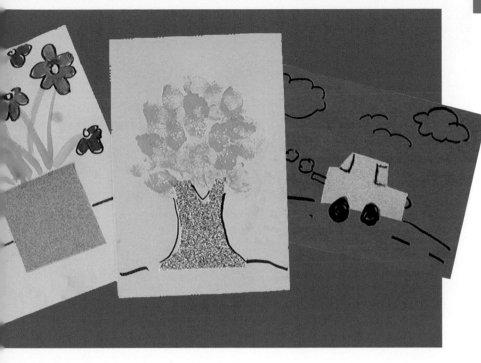

Sandpaper and paint collage

Age range: 5-11

Individual activity

In this activity the children build different textures into a collage by beginning their designs with pieces of sandpaper. Challenge older children to use scraps of different-textured sandpaper to create a sandpaper-only collage.

Steps to follow

1. Let the children choose some sandpaper to use. Ask them to glue it onto the card or cut it into a shape before they glue it in place.

2. The children should then add paint. They may use brushes, sponges or printing gadgets.

3. Let the pictures dry completely then encourage the children to add final details with a black marker pen.

Materials

- 7.5 cm squares of sandpaper in various textures
- 15 x 23 cm for each child
- tempera paint in several colours
- sponges, brushes and gadgets
- black marker pen
- glue

National Curriculum: Art & design
KS1: 2a, 2b, 2c, 3a, 4a, 4b, 5b, 5c
KS2: 2a, 2b, 2c, 3a, 4a, 4b, 5b, 5c
QCA Schemes: Art & design
Unit 1B – Investigating materials
Scottish 5-14 Guidelines: Art & design
Using materials, techniques, skills and media:
Using media; Using visual elements – texture
Expressing feelings, ideas, thoughts
and solutions: Creating and designing;
Communicating

FORM

Learning about form

When a flat, two-dimensional shape is bent, a third dimension is created. The shape becomes a form. Artists use form when they create sculptures. Some forms commonly used are cylinders, cones, spheres, cubes, pyramids and prisms. These forms can be made from a wide range of materials such as clay, wood, paper and recycled items. Creating forms can be for artistic purposes such as sculptures and ornaments or functional purposes such as clay cups and cardboard boxes.

In this section on form, children explore ways of turning two-dimensional card patterns into three-dimensional forms. They also explore ways of creating models out of card by combining two-dimensional shapes and three-dimensional forms. Flexible clay forms are explored and the children learn about the basic clay technique in making pinch pots. By learning to recognise the different types of forms used in art and design the children are able to design and construct original art such as sculpture, collages, clay, models and cards.

What is form?

Age range: 5-11

Class or large-group activity

This activity introduces and investigates how form is created. The children explore how a two-dimensional piece of paper can be turned into a three-dimensional object. Use the activity to discuss the difference between two-dimensional and three-dimensional objects.

Steps to follow

1. Show the can, ball, box and prism to the children. Explain that each is a form because it has three dimensions.

2. Take a plain sheet of paper and ask the children if it is a form. The answer is no because it is flat or two-dimensional.

3. Roll the paper into a cylinder and ask the same question. The answer is now yes because you have added a dimension and made it three-dimensional.

4. Give each child a piece of paper and two pieces of tape. Challenge them to create a form out of the paper. The children may cut or tear their papers to create their forms if they wish.

Materials

- three-dimensional objects: soup can, ball, box, prism, cardboard paper roll etc.

- 10.6 x 28 cm piece of paper for each child

- tape

National Curriculum: Art & design
KS1: 2a, 2b, 2c, 3a, 4a, 4b, 5b, 5c
KS2: 2a, 2b, 2c, 3a, 4a, 4b, 5b, 5c

QCA Schemes: Art & design
Unit 1B – Investigating materials
Unit 1C – What is sculpture?
Unit 3C – Can we change places?

Scottish 5-14 Guidelines: Art & design
Using materials, techniques, skills and media: Using media; Using visual elements – form
Expressing feelings, ideas, thoughts and solutions: Creating and designing; Communicating

2-D to 3-D

Age range: 7-11

Individual activity

This activity lets the children change a two-dimensional shape into a three-dimensional form. They also use skills in cutting out a pattern and following instructions to construct the three-dimensional form. Extend the activity by challenging the children to create their own patterns for three-dimensional forms.

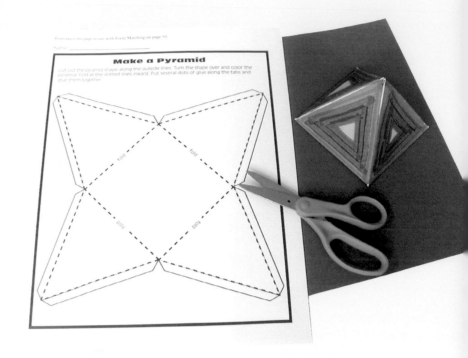

Materials

- scissors
- glue
- marker pens
- a copy of photocopiable page 75 for each child

Steps to follow

1. Ask the children to colour in the two-dimensional design and cut it out.

2. The children should then fold the pattern on the fold lines.

3. Ask them to put a bit of glue on each tab to create the pyramid.

4. Discuss with the children the difference between the two-dimensional shape and the three-dimensional form.

National Curriculum: Art & design
KS2: 2a, 2b, 2c, 3a, 4a, 4b, 5b, 5c

QCA Schemes: Art & design
Unit 3C – Can we change places?

Scottish 5-14 Guidelines: Art & design
Using materials, techniques, skills and media:
Using media; Using visual elements – form
Expressing feelings, ideas, thoughts and
solutions: Creating and designing.
Communicating

Photocopy this sheet for children to use with 2-D to 3-D on page 74.

■■ SCHOLASTIC
PHOTOCOPIABLE

Name _____

Make a pyramid

Cut out the pyramid shape along the outside lines. Turn the shape over and colour in the pyramid. Fold all the dotted lines inwards. Put several dots of glue along the tabs and glue them together.

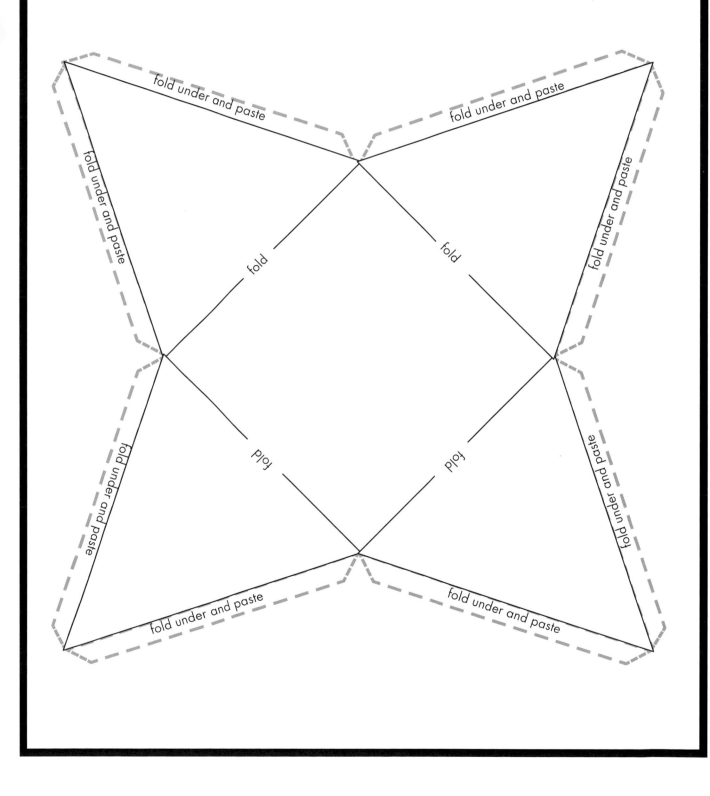

Making a form

Age range: 5-11

Individual activity

This activity allows the children to explore and practise making forms out of modelling clay. Before the activity, encourage the children to think of the basic three-dimensional forms they could model such as spheres, pyramids and cubes. Ask older children to name each of their modelled forms with a descriptive phrase for example 'a no-corner, smooth-all-over ball.'

Materials

(for each child)

- a fist-sized lump of clay
- flat surface for shaping clay
- paper towels

Steps to follow

1. Show the children how to use the clay. Develop guidelines to be followed when working with clay. For example:

 Clay stays on the work surface.
 Put the clay back into its container when you are finished.
 Clay is for modelling, not throwing.

2. Ask the children to use clay to practise modelling basic forms such as spheres, pyramids, boxes and cylinders.

3. When a child has a completed form, ask them to placed it on a paper towel and label it with his or her name for air-drying or firing. If you want to reuse the clay, simply allow the children to share their forms before putting the clay back into its container.

National Curriculum: Art & design
KS1: 2a, 2b, 2c, 3a, 4a, 4b, 5b, 5c
KS2: 2a, 2b, 2c, 3a, 4a, 4b, 5b, 5c

QCA Schemes: Art & design
Unit 1C – What is sculpture?

Scottish 5-14 Guidelines: Art & design
Using materials, techniques, skills and media:
Using media; Using visual elements – form
Expressing feelings, ideas, thoughts and solutions: Creating and designing.
Communicating

Pinch a pot

Age range: 5-11

Individual activity

One basic form that artists often make is a bowl. In this activity, the children learn to use a simple pinch technique to make their own bowls. Older children may want to extend this activity by using the pinch technique to make more sophisticated pots or other clay forms.

Steps to follow

1. Give each child a ball of clay. Explain that it is important to keep the clay in one piece as the form is pinched.

2. Ask the children to stick their thumbs halfway into the clay balls.

3. With their thumbs still in the balls, they should use their other four fingers to gently pinch the clay.

4. They should then gently turn the ball while pinching it so that an even rim is formed.

5. Dry or bake the clay.

Tip

Use baker's clay to create the pinchpots. Bake the pots in the oven. Add coloured accents with permanent markers and glaze.

Baker's Clay

- 1 cup (200 g) salt
- 1 ½ cups (360 ml) warm water
- 4 cups (500 g) flour

1. Mix the salt and water.
2. Add to flour.
3. Stir until combined.
4. Knead for at least five minutes.
5. Store in an airtight container.

Materials

(for each child)

- 5 cm ball of clay
- flat surface for work

National Curriculum: Art & design
KS1: 2a, 2b, 2c, 3a, 4a, 4b, 5b, 5c
KS2: 2a, 2b, 2c, 3a, 4a, 4b, 5b, 5c

QCA Schemes: Art & design
Unit 5B – Containers

Scottish 5-14 Guidelines: Art & design
Using materials, techniques, skills and media:
Using media; Using visual elements – form
Expressing feelings, ideas, thoughts
and solutions: Creating and designing;
Communicating

Stand 'em up

Age range: 5-11

Individual activity

In this activity the children combine pairs of two-dimensional shapes into three-dimensional forms. Encourage the children to investigate the range of forms they could create using the different designs, colour combinations and sizes.

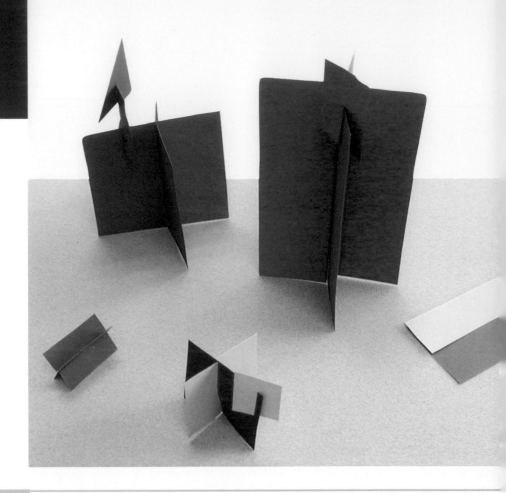

Materials

- brightly coloured card
- scissors

Steps to follow

1. Ask the children to cut two small identical squares or rectangles from card. Shapes should not be larger than 13 cm tall.

2. Ask them to hold the two papers together and cut a slit halfway up.

3. Reversing one of the shapes, the children should slip one shape over the other to create a three-dimensional form.

4. Ask the children to repeat this process to make several forms in different sizes and colours.

National Curriculum: Art & design
KS1: 1a, 1b, 2a, 2b, 2c, 3a, 4a, 4b, 5b, 5c
KS2: 1a, 1b, 2a, 2b, 2c, 3a, 4a, 4b, 5b, 5c

QCA Schemes: Art & design
Unit 1C – What is sculpture?
Unit 3C – Can we change places?

Scottish 5-14 Guidelines: Art & design
Using materials, techniques, skills and media:
Using media; Using visual elements – form
Expressing feelings, ideas, thoughts
and solutions: Creating and designing;
Communicating

SPACE

Learning about space

Space in artwork makes a flat image look like it has form. There are several ways an artist adds space to artwork:

• Overlapping – placing an object in front of another object makes the object in front appear closer than the one behind.

• Changing size – an object that is smaller looks like it is in the distance while an object that is larger looks like it is closer.

• Using perspective – objects can be drawn on a flat surface to give an impression of their relative position and size.

In this section, children explore the concepts of space and perspective by producing a simple overlapping shape picture using different-sized circles. They develop skills in perspective by layering cut-outs in collage to get a sense of distance of different parts. They finally experiment and use their skills in perspective by creating a cityscape using pencil and pen.

Overlapping collage

Age range: 5-11
Individual activity

In this activity the children discover the concept of overlapping and size in creating space. Extend this activity by using different shapes. Older children can experiment with overlapping using irregular shapes or objects.

Materials

- a copy of photocopiable page 81, photocopied onto coloured paper
- 23 x 30.5 cm card in assorted colours
- scissors
- glue
- crayons

National Curriculum: Art & design
KS1: 2a, 2b, 2c, 3a, 4a, 4b, 5b, 5c
KS2: 2a, 2b, 2c, 3a, 4a, 4b, 5b, 5c

Scottish 5-14 Guidelines: Art & design
Using materials, techniques, skills and media: Using media; Using visual elements – space
Expressing feelings, ideas, thoughts and solutions: Creating and designing. Communicating

Steps to follow

1. Ask the children to cut out the different-sized circles on the photocopiable sheet.

2. Let the children choose a sheet of paper in a contrasting colour for the background.

3. The children should arrange their circles on the background paper using overlapping and size to create the illusion that the ball is coming towards the viewer.

4. Discuss the techniques the children found to create the illusion. They should include these ideas:

 • The smallest circle should be the farthest away and at the back.
 • The next smallest circle should overlap a small part of the previous circle.

5. Ask the children to rearrange their circles if necessary and glue them in place.

6. The children may like to use crayons to decorate the largest ball.

Photocopy this sheet onto coloured paper for children to use with
Overlapping collage on page 80.

Name _____

Perspective, one-point!

Age range: 7-11

Individual activity

Perspective is a tool artists use to create space in their artwork. In this activity the children explore the use of one-point perspective using shapes.

Materials

(for each child)

- 21.5 x 28 cm sheet of drawing paper
- ruler
- pencil
- eraser

National Curriculum: Art & design
KS2: 1b, 2a, 2b, 2c, 3a, 4a, 4b, 5b, 5c
Scottish 5-14 Guidelines: Art & design
Using materials, techniques, skills and media:
Using media; Using visual elements – space
Expressing feelings, ideas, thoughts and
solutions: Creating and designing.
Communicating

Steps to follow

1. Ask the children to trace the horizon line parallel to the top and bottom of the paper.

2. They should then place a dot on the horizon line. This is the vanishing point.

3. Ask the children to draw a shape with corners anywhere on the paper.

4. Ask them to use the ruler to connect the corners of the shape to the vanishing point. If the line would have to go across the shape, it should not be drawn.

5. Ask the children to draw the backside of the shape parallel to the front of the shape.

6. They should then erase the lines beyond the shape that connect to the vanishing point.

7. Encourage the children to shade their shapes in different tones of colour.

A sunny day
Age range: 5-11
Individual activity

In this activity, the children explore the concept of perspective by layering cut-outs to create a collage. Explain that the last object to be laid out in the design will appear to be closest. Extend the activity by letting the children create an original scene using four new cut-outs.

Steps to follow

1. Ask the children to cut shapes from the coloured rectangles as follows:

 • yellow – sun

 • green – top of a tree

 • red – house

 • blue – stairs

2. Encourage the children to use scraps of coloured paper to add details to the cut-outs.

3. Ask the children to layer the cut-outs on the black paper. The farthest away should be in the back. When they are happy with the arrangement, they can glue the pieces in place.

Materials

(for each child)

• 15 x 30.5 cm black card

• 10 x 15 cm sheets of card – one each of yellow, green, red and blue

• scissors

• glue

National Curriculum: Art & design
KS1: 2a, 2b, 2c, 3a, 4a, 4b, 5b, 5c
KS2: 2a, 2b, 2c, 3a, 4a, 4b, 5b, 5c
QCA Schemes: Art & design
Unit 1B – Investigating materials
Unit 4A – Viewpoints
Scottish 5-14 Guidelines: Art & design
Using materials, techniques, skills and media: Using media; Using visual elements – space
Expressing feelings, ideas, thoughts and solutions: Creating and designing. Communicating

A city in perspective

Age range: 7-11

Individual activity

In this activity, the children use their skills in one-point perspective to create a cityscape that looks three-dimensional. Extend the activity by asking the children to create a contrasting landscape using one-point perspective.

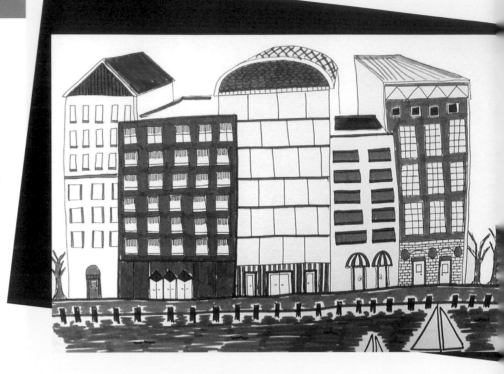

Materials

(for each child)

- 30.5 x 46 cm white card
- ruler
- pencil
- coloured markers

National Curriculum: Art & design
KS2: 2a, 2b, 2c, 3a, 4a, 4b, 5a, 5b, 5c
QCA Schemes: Art & design
Unit 6C – A sense of place
Scottish 5-14 Guidelines: Art & design
Using materials, techniques, skills and media:
Using media; Using visual elements – space
Expressing feelings, ideas, thoughts and
solutions: Creating and designing;
Communicating

Steps to follow

1. Ask the children to draw a horizontal line about 5 cm from the bottom of the paper.

2. Along the line, they should draw at least five different rectangles for building fronts.

3. Ask the children to draw a vanishing point on the top edge of the paper.

4. Ask them to connect the corners of the buildings to the vanishing point. If a line goes through a building, it should not be drawn.

5. Ask them to add the backs and sides of the buildings by making lines parallel to the front lines.

6. They should then erase the extra lines that continue to the vanishing point.

7. Ask the children to add details to the buildings such as windows, doors, signs, shingles, chimneys and TV aerials.

8. The children can then trace over the pencil lines carefully with the black marker and use coloured markers to add colour to the buildings.

How to use part two

The following activities help children to see how famous artists from ancient times to the present have used the basic elements of art to express themselves.

The activities

There are 24 activities in part two of *How to Teach Art to Children*. Each
activity is based on the work of a famous artist and includes the following
components:

- a brief background statement about the artist

- a list of the art elements used in the activity

- a list of materials needed

- step-by-step instructions for the activity.

Using the activities

Follow these simple steps to use the activities:

- Choose the activities you want to use. The simplest ones are presented first, but all can be adapted to your pupils' ages and abilities.

- Gather examples of the featured artist's work. Books and magazines, museum catalogues and web galleries are great resources.

- Explain the activity to the children. Encourage creativity.

- Allow time for the thoughtful completion of the activities.

- Discuss your pupils' activities and how they might parallel those of the famous artist.

- Display the finished art.

Twittering machines

Materials

- photograph of Paul Klee's *Twittering Machine*

For each child:

- 30.5 x 46 cm white card
- black crayon
- watercolour paints
- water containers
- paintbrushes

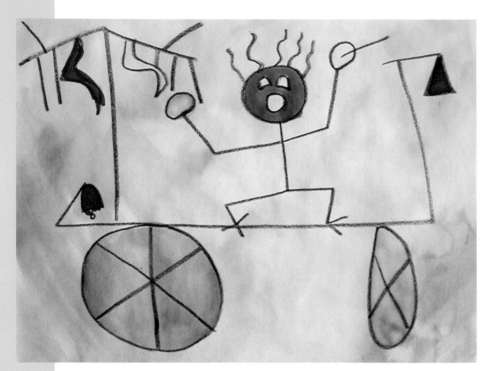

1

2

3

Art elements

Line

Shape

Colour

Talk about...

Show the children Paul Klee's *Twittering Machine*. Talk with the children about Paul Klee and his love for music. Ask:

- What type of music do you think the twittering machine plays?
- If you could create your own twittering machine, what types of sounds might it make?
- What would it look like?
- What kinds of colours did Paul Klee use in this artwork?

Steps to follow

1. Give each child a piece of paper and a black crayon. Challenge them to design their own twittering machines. They should use lines and shapes to draw their machines then add lots of extra details.

2. First, the children should wet the entire paper using paintbrushes and water. They can then drop in cool colours. The drops will spread out on the wet paper and blend together. Let the paintings dry.

3. Ask the children to add just a little bit of a warm colour to the inside of some of the shapes. Let the paintings dry again.

4. Let the children sign their artwork and it is ready to display.

Paul Klee

Paul Klee was a German-Swiss painter who lived from 1879 to 1940. He loved music and played the violin. He was interested in creating a deep meaning in his art by using symbols. He was very imaginative in his works. His work called *Twittering Machine* hangs in The Museum of Modern Art in New York. This work is a pen-and-ink drawing with watercolour. It depicts an imaginary machine that looks like it may make music when the handle is turned.

National Curriculum: Art & design
KS1: 1a, 1b, 2a, 2b, 2c, 4a, 4b, 4c, 5b, 5c, 5d
KS2: 1a, 1b, 2a, 2b, 2c, 4a, 4b, 4c, 5b, 5c, 5d
Scottish 5-14 Guidelines: Art & design
Using materials, techniques, skills and media: Using media; Using visual elements
Expressing feelings, ideas, thoughts and solutions: Creating and designing; Communicating
Evaluating and appreciating: Observing, reflecting, describing and responding

Prints

Age range: 5-11 years

Materials

- example of Piet Mondrian's artwork

For each child:

- thick string
- 20 x 25.5 cm piece of cardboard
- scissors
- masking tape
- black paint
- paintbrush
- 20 x 25.5 cm white card
- drying rack
- red, yellow and blue crayons

2

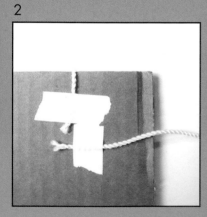

3

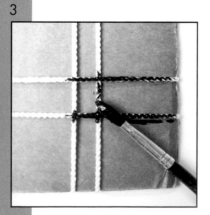

4

Art elements

Line

Shape

Colour

Talk about...

Show the example of Piet Mondrian's artwork and ask the children to describe it. Ask:

• What colours can you see?

• What types of lines? How are the lines placed?

• What shapes can you see? Is this a picture of something you recognise?

Steps to follow

1. Give each child a piece of cardboard and paper, several metres of string and several pieces of tape.

2. Ask the children to wrap a total of five pieces of string around their boards, both vertically and horizontally. Ask them to cut the string and tape the ends on the back to keep the string tightly in place. This becomes a printing plate.

3. The next step is to paint the string with black paint. This process is called inking the printing plate.

4. Ask the children to position the printing plate paint-side down on the white paper and to press it down to print the image of the black lines onto the paper. When they remove it, they should lift it straight up to avoid smudging.

5. Place the prints on a drying rack to dry.

6. Look again at Piet Mondrian's artwork. Ask the children to notice if every shape is coloured. Ask if all the coloured shapes are right next to each other or spread apart.

7. Using the crayons, ask the children to fill in three shapes with yellow, two with red and four with blue. The coloured shapes should be spread out just like in Mondrian's paintings.

Piet Mondrian

Piet Mondrian was born in 1872 and lived until 1944. He worked to create his own simple style of painting, and in the early 1900s he evolved his very modern style. Mondrian used only vertical and horizontal straight lines and the three primary colours (red, yellow and blue) with black and white.

National Curriculum: Art & design
KS1: 1b, 2a, 2b, 2c, 3a, 4a, 4b, 4c, 5b, 5c, 5d
KS2: 1b, 2a, 2b, 2c, 4a, 4b, 4c, 5b, 5c, 5d

QCA Schemes: Art & design
Unit 3B – Investigating pattern
Unit 4A – Viewpoints

Scottish 5-14 Guidelines: Art & design
Using materials, techniques, skills and media:
Using media; Using visual elements
Expressing feelings, ideas, thoughts
and solutions: Creating and designing;
Communicating
Evaluating and appreciating: Observing,
reflecting, describing and responding

Sunflowers

Age range: 5-11 years

Materials

- photograph of one of Vincent Van Gogh's paintings showing sunflowers in a vase

For each child:

- 23 x 30.5 cm blue card for the background
- 15 x 23 cm yellow card for the vase
- 7.5 cm square of orange card for the sunflower centre
- 2.5 x 15 cm green card for the stem
- yellow, red and orange tissue paper, torn in strips
- dried black beans
- scissors
- glue
- light-coloured and orange chalk
- tissues

2a

2b

3, 4

7

Art elements

Line

Shape

Colour

Texture

Space

Talk about...

Discuss an example of Vincent Van Gogh's *Sunflowers*. Ask:

• What colours did Van Gogh use in the background?

• What about the sunflowers? The vase?

• Are the colours warm or cool?

Steps to follow

1. On the piece of blue card, ask the children to draw a line one-quarter of the way up from the bottom with light chalk and fill in the table area below the line. They can use tissues to blend the chalk.

2. Ask the children to cut out a vase shape from the yellow card and lay it on their blue background. Using a piece of orange chalk, ask them to make a line down the side of the vase then to rub the chalk line with tissue to create a shadow effect. The chalk shadow helps to create an illusion of space.

3. The next step is to position the green card strip stem in the vase.

4. Allow the children to arrange the tissue strips in a flower shape on the background paper.

5. They should then round the corners of the orange square to make the sunflower centre and lay it on top of the tissue strips.

6. Ask the children to glue the petals, stem, flower centre and vase in place.

7. Ask the children to glue black beans onto the sunflower centre. The beans add the texture.

8. Allow the children to sign their artwork and admire the beautiful sunflowers!

Vincent Van Gogh

Vincent Van Gogh (1853–1890) is famous for his use of raw colour and wild brushstrokes. He became a painter after failing at many other careers. He painted day and night. He would set up still-life arrangements to paint indoors when he couldn't paint outside. He painted his food, his shoes and sunflowers in vases. His sunflowers are fun to look at, with their wild, bright-yellow petals and their large dark centres. The vase he placed them in was also bright and yellow.

National Curriculum: Art & design
KS1: 1a, 1b, 2a, 2b, 2c, 4a, 4b, 4c, 5b, 5c, 5d
KS2: 1a, 1b, 2a, 2b, 2c, 4a, 4b, 4c, 5b, 5c, 5d

QCA Schemes: Art & design
Unit 1B – Investigating materials
Unit 2B – Mother Nature, designer
Unit 5A – Objects and meanings

Scottish 5-14 Guidelines: Art & design
Using materials, techniques, skills and media: Investigating visually and recording; Using media; Using visual elements
Expressing feelings, ideas, thoughts and solutions: Creating and designing; Communicating
Evaluating and appreciating: Observing, reflecting, describing and responding

Clay cartouches

Age range: 5-11 years

Materials

- an example of a cartouche containing hieroglyphs

For each child:

- hieroglyphic alphabet on page 94
- oval cartouche pattern on page 95
- pencil
- clay
- paper clip
- brown tempera paint
- paintbrush
- paper towels

1

2

3

4

Art elements

Line

Shape

Talk about...

Show the example of the hieroglyphs. Relate the hieroglyphs to the alphabet. Point out the cartouche in the picture. Explain that the cartouche spells a name.

Steps to follow

1. Ask the children to place their oval cartouche pattern over the hieroglyphic alphabet paper and to trace the characters that spell their name.

2. The children should then turn the pattern over and scribble with pencil on the backside. This creates a form of carbon paper so that when the pattern is placed on the clay, they can trace over the lines and transfer the symbols onto the clay.

3. Ask the children to roll a 0.5 cm thick layer of clay. Ask them to trace over the pattern and hieroglyphs on top of the clay with a pencil to transfer the design onto the clay.

4. The children can use the paper clip to cut away the extra clay along the outside of the cartouche pattern and to reinforce the pencil lines.

5. Let the clay dry and then fire it, bake it or set up the clay as directed by the manufacturer.

6. Ask the children to paint the entire cartouche with a thin layer of brown paint.

7. After painting, they should quickly wipe off the paint with a paper towel so that it remains only in the crevices.

Ancient Egyptians

In ancient times, Egyptians used hieroglyphs to write messages in stone and on papyrus. The hieroglyphs (pictures and symbols) used by the Egyptians were their alphabet. By combining the pictures, the Egyptians could spell out words. On the walls of the pyramids, the messages contain groups of hieroglyphs that are surrounded by an oval. These ovals with hieroglyphs in them are called cartouches. The hieroglyphs inside a cartouche spell a name.

National Curriculum: Art & design
KS1: 1b, 2a, 2b, 2c, 3a, 4a, 4b, 4c, 5b, 5c, 5d
KS2: 1b, 2a, 2b, 2c, 3a, 4a, 4b, 4c, 5b, 5c, 5d

QCA Schemes: Art & design
Unit 1C – What is sculpture?

Scottish 5-14 Guidelines: Art & design
Using materials, techniques, skills and media: Using media; Using visual elements
Expressing feelings, ideas, thoughts and solutions: Creating and designing; Communicating
Evaluating and appreciating: Observing, reflecting, describing and responding

Photocopy this sheet for children to use with Clay cartouches on page 93.

■ SCHOLASTIC
PHOTOCOPIABLE

Name

Hieroglyphic alphabet

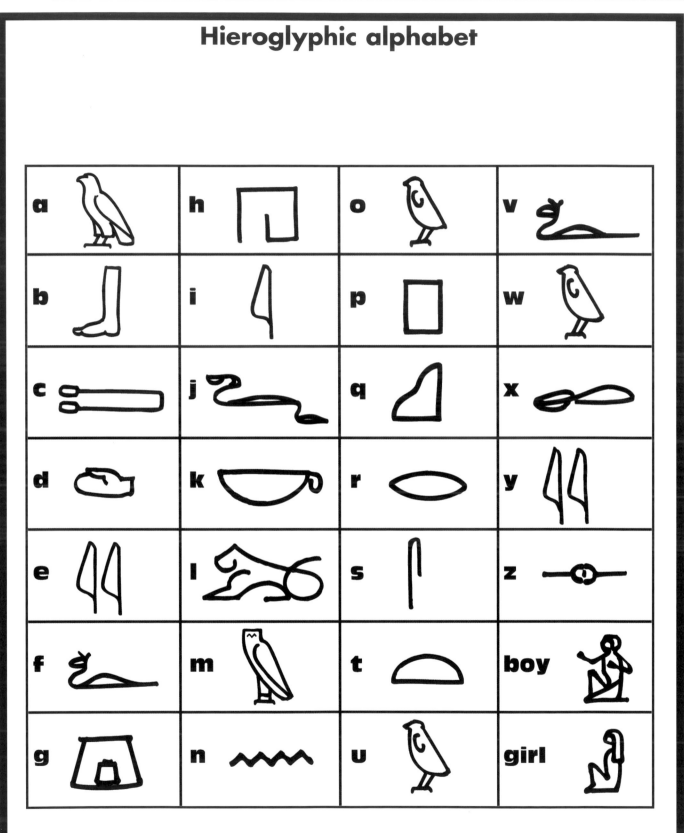

Photocopy this pattern for children to use with Clay cartouches on page 93.

SCHOLASTIC
PHOTOCOPIABLE

Name _____

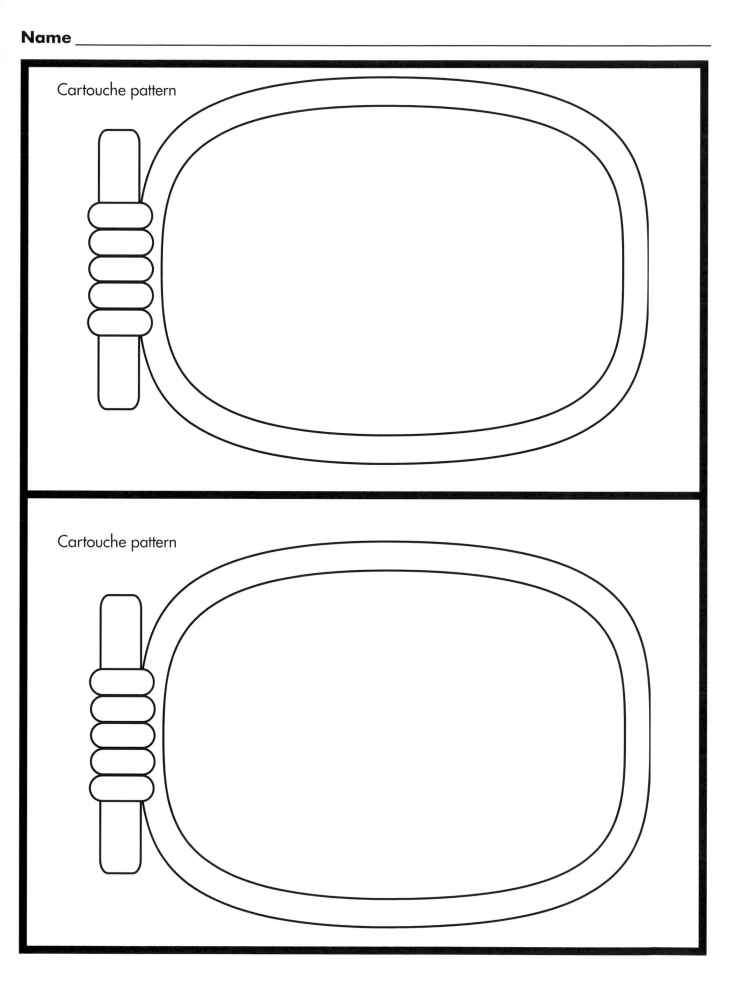

Cartouche pattern

Cartouche pattern

Adinkra cloth

Age range: 5-11 years

Materials

- sample or picture of Adinkra cloth

For each child:

- 23 cm square of brown card
- ruler
- black crayon
- gadgets to print with (objects that you have collected that will make an interesting image when inked and then stamped)
- black printing ink or tempera paint
- washable, portable flat surface or plate

1

2a

2b

This project uses the design of an Adinkra cloth, substituting gadget prints for the elaborate stamps made by the Ashanti peoples.

Art elements

Line

Shape

Talk about...

Talk to the children about Adinkra cloth and the Ashanti peoples. Find Ghana on a map or globe. Ask the children if they notice anything in the Adinkra cloth (lines, shapes, repeated patterns).

Steps to follow

1. Ask the children to make a border of straight lines around the card square using a ruler and black crayon.

2. Let the children choose a gadget and print the same object in a repeating pattern on their square. To do this they should:

 • Pour a puddle of paint or ink on a flat surface or plate.
 • Spread the paint or ink into an even layer.
 • Place the gadget to be printed in the paint.
 • Press the paint edge of the gadget onto the paper.
 • Lift straight up.

3. Once the squares are printed, let the paint dry completely. The squares may be combined to create a class Adinkra cloth. You may want to add multicoloured ribbon to represent the colourful stitches used to hold the strips of Adinkra cloth together.

Ashanti peoples

Adinkra cloth is made by the Ashanti peoples in Ghana, Africa. They use black ink to print symbols with different meanings on fabric. They make stamps out of gourds. Then they apply ink to the stamps and press them on the fabric. They may separate squares of the designs with lines. The Ashanti often sew the pieces of cloth together with brightly coloured thread to make clothes for special ceremonies.

National Curriculum: Art & design
KS1: 1b, 2a, 2b, 2c, 3a, 4a, 4b, 4c, 5b, 5c, 5d
KS2: 1b, 1c, 2a, 2b, 2c, 4a, 4b, 4c, 5b, 5c, 5d

QCA Schemes: Art & design
Unit 1B – Investigating materials
Unit 3B – Investigating pattern

Scottish 5-14 Guidelines: Art & design
Using materials, techniques, skills and media:
Using media; Using visual elements
Expressing feelings, ideas, thoughts
and solutions: Creating and designing;
Communicating
Evaluating and appreciating: Observing,
reflecting, describing and responding

Pop-up collage cards

Materials

- examples of Henri Matisse's paper collages

For each child:

- 23 x 30.5 cm white card
- scraps in various colours
- scissors
- glue
- pencil

card closed

card opened

2a, b, c

2e

2g

2h

Art elements

Shape

Colour

Form

Talk about...

Talk about Matisse's cut-outs and the reason he began doing cut-outs rather than paintings. Point out the different shapes and colours that Matisse used.

Steps to follow

1. Give the children a piece of white card.

2. Ask them to fold their papers to make a pop-up card, using the following method:
 a. Fold the paper in half lengthwise.
 b. Fold the top corner (fold side) down to the open edge.
 c. Turn the paper over and reverse the fold.
 d. Open the paper.
 e. Pull the top centre fold inside and to the left side of the page. Press the folds firmly.
 f. Open the paper again.
 g. Fold the bottom to meet the top. Press the fold firmly.
 h. Close the card so that the plain side is outside and the triangle fold is inside. Press firmly again.

3. Let the children choose three colours of paper scraps. Ask them to cut out and arrange shapes on the inside and outside of their cards.

4. Once the shapes are arranged, they should use dots of glue to attach the shapes to the card. Let the glue dry.

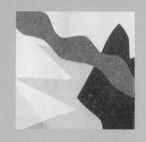

Henri Matisse

Henri Matisse (1869–1954) painted large vibrant canvases in his early career. Later in his life, Matisse became ill and was confined to a wheelchair. Because he could no longer stand up at his canvases, he began to cut out paper designs and arrange them in attractive compositions. His Jazz series is very famous.

National Curriculum: Art & design
KS2: 1b, 2a, 2b, 2c, 4a, 4b, 4c, 5b, 5c, 5d
QCA Schemes: Art & design
Unit 3B – Investigating pattern
Scottish 5-14 Guidelines: Art & design
Using materials, techniques, skills and media: Using media; Using visual elements
Expressing feelings, ideas, thoughts and solutions: Creating and designing; Communicating
Evaluating and appreciating: Observing, reflecting, describing and responding

Drawing an invention

Materials

- examples of Leonardo da Vinci's invention drawings

For each child:

- practice paper
- 23 x 30.5 cm manila paper
- pencil
- eraser
- ruler
- brown marker pen
- brown card

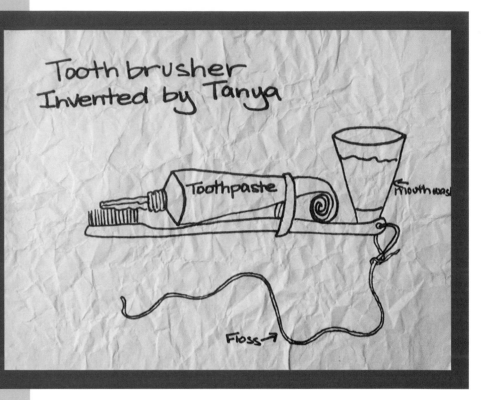

4

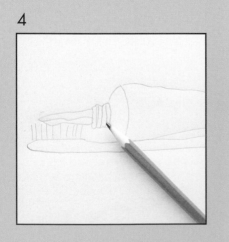

5

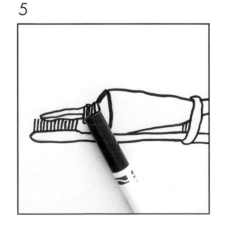

6

Art elements

Line

Shape

Texture

Talk about...

Show the children examples of Leonardo da Vinci's drawings. Ask them what they think the different machines might do. Does it look as if Leonardo da Vinci took time to draw these inventions or did he just scribble them out? Encourage the children to think about what invention they would make to help them in their lives.

Steps to follow

1. Tell the children that they are now inventors like Leonardo da Vinci. Ask them to draw a machine that will help them do something. Ask the children to draw three different ideas on the practice paper. Artists always come up with more than one idea!

2. Help the children to choose one of their drawings or encourage them to combine several of their ideas together in one machine.

3. Once children have chosen their machines, give them a piece of manila paper.

4. Ask the children to draw their machines in pencil on their paper. They may add written instructions on their paper as well.

5. Ask them to trace over their pencil lines with brown marker.

6. The children could add texture to the paper to make it look old by crumpling it and uncrumpling it several times.

7. Mount the drawings on brown paper and display the creative ideas.

Leonardo da Vinci

Leonardo da Vinci (1452–1519) is a well-known artist and inventor. He was born in Italy in 1452. Leonardo da Vinci was known as a 'Renaissance Man'. He loved learning. He not only painted one of the world's most famous portraits, *Mona Lisa*, but he also made many contributions to science. He was an inventor too. Leonardo da Vinci's drawings included ideas for many different inventions. He was always thinking! He even wrote backwards to keep people from stealing his ideas!

National Curriculum: Art & design
KS1: 1a, 1b, 2a, 2b, 2c, 4a, 4b, 4c, 5b, 5c, 5d
KS2: 1a, 1b, 2a, 2b, 2c, 4a, 4b, 4c, 5b, 5c, 5d
QCA Schemes: Art & design
Unit 1B – Investigating materials
Scottish 5-14 Guidelines: Art & design
Using materials, techniques, skills and media:
Using media; Using visual elements
Expressing feelings, ideas, thoughts
and solutions: Creating and designing;
Communicating
Evaluating and appreciating: Observing,
reflecting, describing and responding

Ballerina paintings

Age range: 5-11 years

Materials

- examples of Edgar Degas' ballerinas
- tutu and ballerina shoes for model

For each child:

- 30.5 x 46 cm white paper
- pencil
- eraser
- thin black marker pen
- oil pastels
- tempera paint in brown, green, blue and purple
- paintbrushes

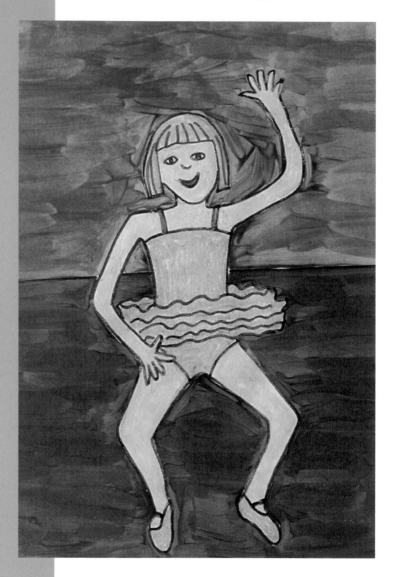

2, 3, 4

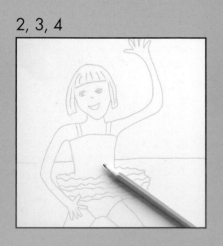

5, 6, 7

8

Art elements

Line

Colour

Talk about...

Show examples of Degas' ballerinas. Ask the children to describe details about the dancers. Ask them if they have ever seen a ballerina.

Steps to follow

1. Choose a child to be the first model. Ask the model put on the tutu and shoes. The model should pretend to be dancing and strike a pose.

2. Ask the rest of the children to draw the model quickly in pencil. They should use light pressure on the paper so they can erase if necessary

3. Give the children time to add details to the dancer.

4. Ask the children to draw in a line for the back of the stage.

5. They should then carefully trace over all lines with a black marker pen.

6. Ask the children to carefully paint the stage brown, leaving the ballerina unpainted.

7. Ask them to choose a cool colour (green, blue or purple) and to paint the background, again being careful not to paint over the ballerina. Let the paint dry.

8. Show the children how to use oil pastels. Ask them to colour in their ballerinas with oil pastels. They should use a skin colour for skin and whatever colour they want for the costume, hair and eyes.

Edgar Degas

Edgar Degas (1834–1917) is famous for his paintings of ballerinas. He painted with Claude Monet during the impressionist movement. However, Degas did not use short brushstrokes like Monet. Degas preferred to use a more realistic style. The dancers in Degas' paintings look like they might have been photographed. Degas was able to capture a single moment in his paintings and save it for many people to look at.

National Curriculum: Art & design
KS1: 1a, 1b, 2a, 2b, 2c, 4a, 4b, 4c, 5b, 5c, 5d
KS2: 1a, 1b, 2a, 2b, 2c, 4a, 4b, 4c, 5b, 5c, 5d

QCA Schemes: Art & design
Unit 4A – Viewpoints
Unit 6A – People in action

Scottish 5-14 Guidelines: Art & design
Using materials, techniques, skills and media: Using media; Using visual elements
Expressing feelings, ideas, thoughts and solutions: Creating and designing; Communicating
Evaluating and appreciating: Observing, reflecting, describing and responding

Accordion books

Age range: 5-11 years

Materials

For each child:

- two 10 x 13 cm pieces of red cardboard
- 1.5 x 38 cm white card
- stamp with different shapes made from foam material, mounted on a wooden block or jar lid
- gold tempera paint
- flat surface or plate
- glue
- 51 cm black ribbon or wool
- pencil
- crayons
- black marker pen

1

2

3

4

Art elements

Line

Shape

Colour

Talk about...

Discuss the history of bound books. Be sure to mention China and the invention of accordion books. Tell the children that they are going to make their very own accordion book.

Steps to follow

1. Ask the children to fold the long white paper into accordion pages using the following method:

 • Fold the paper in half.

 • Fold the top end back to meet the fold and crease a new fold.

 • Turn the paper over and do the same on the other side.

2. Ask the children to create a stamp by cutting foam material in a repeating design then glueing the pieces to a wooden block or jar lid.

3. The children should press their stamps into the gold paint and print a pattern on their red cardboard covers. Let the paint dry thoroughly.

4. The children can put the books together as follows:

 • Lay the back cover with the decorated side touching the table.

 • Lay the ribbon or wool so the middle of it is in the middle of the back cover.

 • Glue on the back end of the accordion-folded white paper and lay it down on the cover.

 • Place a few drops of glue on the front end of the accordion pages and place the top cover on the book with the printed side facing out.

5. The books are finished and ready for filling with wonderful stories or for the children to use as a personal journal. Lines may be lightly pencilled in for writing or the children may use the book as a sketch pad for their drawings.

Chinese bookmakers

Books with hard covers were first made in China.

• Before the invention of hard covers, long strips of paper were rolled into scrolls.

• These long strips of paper evolved into accordion books with hard covers.

• Later, the edges of the hard covers were sewn together on one side.

The Chinese also created a printing process that used carved blocks of wood to print images in books.

One strong symbol in the Chinese culture is the dragon. It stands for truth, life, power, nobility and fortune. The dragon is often gold, green or red, or a combination of all three colours.

National Curriculum: Art & design
KS1: 1b, 2a, 2b, 2c, 3a, 4a, 4b, 4c, 5b, 5c, 5d
KS2: 1b, 2a, 2b, 2c, 3a, 4a, 4b, 4c, 5b, 5c, 5d
QCA Schemes: Art & design
Unit 1B – Investigating materials
Unit 3B – Investigating pattern
Scottish 5-14 Guidelines: Art & design
Using materials, techniques, skills and media:
Using media; Using visual elements
Expressing feelings, ideas, thoughts
and solutions: Creating and designing;
Communicating
Evaluating and appreciating: Observing,
reflecting, describing and responding

Pattern portraits

Age range: 5-11 years

Materials

- example of a portrait by Henri Matisse (try to find one that uses many patterns)
- clothing and fabric with patterns
- vase with flowers
- table
- chair

For each child:

- white drawing paper
- pencil
- tempera paint in black and assorted colours
- paintbrushes
- skin-tone oil pastels
- 30.5 x 46 cm black card
- glue

2, 3

4

5

Art elements

Line

Shape

Colour

Henri Matisse

Henri Matisse (1869–1954) was born in France. He studied to be a lawyer and then became an artist at the age of 23. Matisse used a lot of patterns in his paintings. In his travels he collected patterned fabrics from different places and looked at them as he painted. Matisse liked to paint with expressive lines and forms. His paintings are colourful and full of energy.

Talk about...

Talk about Matisse and his portraits. Ask the children to locate the patterns in the paintings. Talk about Matisse's travels and how he collected fabrics to use in his paintings. Ask the children if the person in the painting is drawn proportionally.

Steps to follow

1. Set up a live still life with a chair, patterned fabric on the table and a model from the class dressed in patterned clothes. Ask the children to sketch the scene lightly in pencil on the white paper.

2. The children should then trace the pencil lines using a thin brush and black paint. Let the paintings dry.

3. Ask the children to sketch in a patterned background behind the model.

4. Ask them to paint in colourful patterns in the background and clothes, leaving the skin blank. Let the paintings dry.

5. The children can then fill in all the skin areas with the skin-tone oil pastels.

6. Mount the paintings on black paper and display them for all to enjoy.

National Curriculum: Art & design
KS1: 1a, 1b, 2a, 2b, 2c, 4a, 4b, 4c, 5b, 5c, 5d
KS2: 1a, 1b, 2a, 2b, 2c, 4a, 4b, 4c, 5b, 5c, 5d

QCA Schemes: Art & design
Unit 3B – Investigating pattern
Unit 6A – People in action

Scottish 5-14 Guidelines: Art & design
Using materials, techniques, skills and media:
Using media; Using visual elements
Expressing feelings, ideas, thoughts
and solutions: Creating and designing;
Communicating
Evaluating and appreciating: Observing,
reflecting, describing and responding

Still lifes

Age range: 7-11 years

Materials

- example of a still life painted by Paul Cézanne
- white tablecloth, tall vase and various fruits

For each child:

- 28 x 43 cm blue card
- 15 x 43 cm white card
- 13 x 18 cm grey card
- scraps of card in warm colours
- scissors
- glue
- black and white chalk
- tissues

2

3

4

5

Art elements

Line

Shape

Colour

Tone

Space

Form

Talk about...

Discuss Paul Cézanne and his artwork with the children. Show one of his still-life paintings and ask them what they think a still life is. Ask the children to notice the tones (lights and darks) in Cézanne's paintings.

Steps to follow

1. Set up a still life with a white tablecloth, a tall vase and various fruits.

2. Ask the children to make the tablecloth from the white card. One edge should be wavy to represent the folds along the top of the tablecloth. Ask the children to glue the tablecloth to the blue background paper.

3. The next step is for the children to cut out a vase from the grey paper. The vase may be cut on a folded sheet of paper so that it is symmetrical.

4. The children can then cut out coloured fruit and arrange the vase and fruit on their tablecloths. The children can create space in their designs by overlappping the shapes. Once they are happy with their composition, they should glue their shapes in place.

5. Show the children how to use the black chalk on one side of the shapes (vase and fruit) and the white chalk on the other side of the shapes to add form to the flat shapes. Explain that they are using tone just like Cézanne did in his still life paintings. Let the children blend the lines of chalk with tissue.

6. Children may also add blended chalk lines to create folds in the fabric of the tablecloth.

Paul Cézanne

Paul Cézanne (1839–1906) was one of the leading artists at the end of the 19th century. He is well known for his paintings of landscapes and still lifes. Cézanne worked hard to use colour and tone to give his paintings depth. He believed that using contrasting tones and colours made his drawings and paintings successful.

National Curriculum: Art & design
KS2: 1a, 1b, 2a, 2b, 2c, 4a, 4b, 4c, 5b, 5c, 5d

QCA Schemes: Art & design
Unit 3B – Investigating pattern
Unit 5A – Objects and meanings

Scottish 5-14 Guidelines: Art & design
Using materials, techniques, skills and media:
Investigating visually and recording; Using
media; Using visual elements
Expressing feelings, ideas, thoughts
and solutions: Creating and designing;
Communicating
Evaluating and appreciating: Observing,
reflecting, describing and responding

Musician collages

Age range: 5-11 years

Materials

- photograph of Pablo Picasso's *Three Musicians*

For each child:

- scraps of wallpaper and wrapping paper
- 30.5 x 46 cm black card
- 28 x 43 cm green card
- scraps of card in black, white and assorted colours
- scissors
- glue
- black permanent marker pen
- scraps of gold foil paper

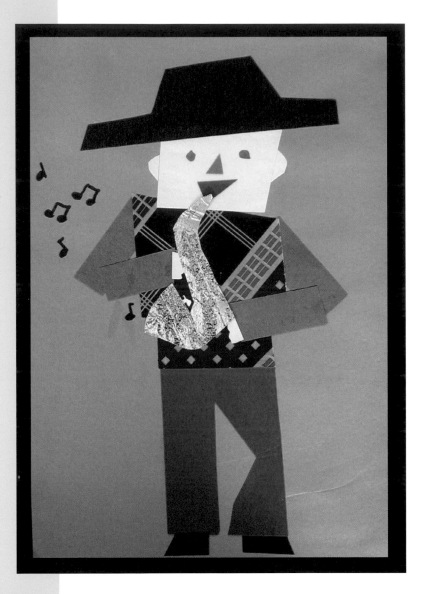

1

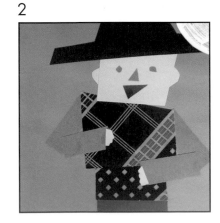

2

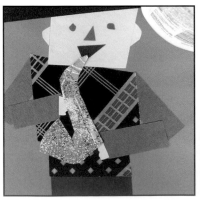

3

Art elements

Line

Shape

Colour

Texture

Talk about...

Show the children a photograph of Picasso's *Three Musicians*. Ask them to find the three musicians and their instruments. Ask:

- What do you notice about the people?
- Are they realistic or stylised?
- What types of shapes can you see?

Steps to follow

1. Ask the children to cut out shapes from the scraps of card to make their musicians. They should give their musicians a hat like those in the painting and use patterned paper for their clothes. Encourage the children to use mostly squares and rectangles.

2. Give the children time to arrange the shapes to create their musicians on the green paper. Once they are happy with their layouts, they can glue the shapes in place.

3. Let each child choose an instrument for their musician to play. Ask them to cut out their chosen instrument from the gold foil paper and to glue it in place.

4. The children can add details with a permanent black marker.

5. Mount the pictures on black paper and share them with the class.

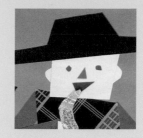

Pablo Picasso

Pablo Picasso was born in Spain in 1881 and died in France in 1973. Picasso was always shocking people with his artwork. His painting style changed more over the period of his life than that of any other great artist. He helped invent a kind of art called Cubism. A lot of his paintings look like he has broken the object he was painting into blocks or cubes. He was also one of the first artists to use a collage technique by adding in different objects to his paintings.

National Curriculum: Art & design
KS1: 1b, 2a, 2b, 2c, 3a, 4a, 4b, 4c, 5b, 5c, 5d
KS2: 1b, 2a, 2b, 2c, 4a, 4b, 4c, 5b, 5c, 5d

QCA Schemes: Art & design
Unit 1B – Investigating materials
Unit 3B – Investigating pattern
Unit 5C – Talking textiles
Unit 6A – People in action

Scottish 5-14 Guidelines: Art & design
Using materials, techniques, skills and media:
Using media; Using visual elements
Expressing feelings, ideas, thoughts
and solutions: Creating and designing;
Communicating
Evaluating and appreciating: Observing,
reflecting, describing and responding

Tessellations

Age range: 7-11 years

Materials

- examples of M.C. Escher's tessellations

For each child:

- 7.5 cm card square
- scissors
- tape
- crayons and coloured pencils
- pencil
- practice paper
- 23 x 30.5 cm white paper
- black fine-point marker pen

1

3

4

5

Art elements

Line

Shape

Colour

Talk about...

The word tessellation comes from *tessella*, which is a small stone or tile used in Roman mosaics. We can find tessellations everywhere around us in tile, wallpaper and fabric designs. Talk about M.C. Escher and his artwork. Discuss tessellations. Look for examples of tessellation around the room.

Steps to follow

1. Ask the children to make a template shape from the square of card using the following method.

 - Use a crayon to colour one side of the square. The other side is left white. Use the coloured side.
 - Starting at the upper left corner and ending at the lower left corner of the same side, cut an interesting line.
 - Slide the cut piece straight across the square and tape it on the opposite side.
 - Using the same technique, cut a line from the bottom left corner to the bottom right corner.
 - Slide the piece straight up and tape it on the top of the square.

2. Ask the children to decide what this shape will be. Will it be an animal, an object or just a design? Ask them to lightly pencil in the defining lines on the template.

3. Let the children begin tracing the template onto the white paper. They should place the template in the bottom left corner of the paper and trace carefully around it. They should then move the template to the right and fit it into the edge of the first tracing. There should be no gaps. They should continue to trace and move the template like this until they fill the entire paper with their shape.

4. Ask the children to add the details inside their shape in pencil. The sample shape has been made into a horse. Children can then carefully trace over their pencil lines with a black fine-point marker pen.

5. Ask the children to use crayons or coloured pencils to colour in their tessellations.

M.C. Escher

Maurits Cornelius Escher was born in the Netherlands in 1898 and died in 1972. His interest in tessellation developed after seeing a tile floor in Spain in 1936. He worked to animate the tessellating shapes instead of working with abstract geometrical designs. Escher incorporated his animated tessellation into his woodcuts and lithographs.

National Curriculum: Art & design
KS2: 1b, 2a, 2b, 2c, 4a, 4b, 4c, 5b, 5c, 5d
QCA Schemes: Art & design
Unit 3B – Investigating pattern
Scottish 5-14 Guidelines: Art & design
Using materials, techniques, skills and media: Using media; Using visual elements
Expressing feelings, ideas, thoughts and solutions: Creating and designing; Communicating
Evaluating and appreciating: Observing, reflecting, describing and responding

Pop art sculptures

Age range: 5-11 years

Materials

- pictures of Claes Oldenburg's sculptures

For each child (or group):

- practice paper
- pencil
- boxes, balloons, paper tubes and other objects to help create a base for sculpture
- cardboard
- scissors
- tape
- newspaper torn in strips
- papier-mâché paste
- bowl
- tempera paint
- paintbrushes
- markers
- wire, aluminium foil and string
- glue

2

3

5

Art elements

Shape

Colour

Form

Texture

Talk about...

Show the pictures of Claes Oldenburg's sculptures and talk about Pop Art. Ask the children what objects they think a pop artist would choose to represent today. Ask the children to look around the room to find an ordinary object they would like to make into a large sculpture. (You may want to break the class into groups if you want several children to work on one sculpture. Several hands will probably be more helpful.)

Steps to follow

1. Ask each child, or group, to choose an object and make a drawing of it.

2. Ask them to make the basic form of the object using boxes, balloons or tubes, and tape.

3. The children should then cover their object with newspaper strips dipped in the papier-mâché paste.

4. Let the sculpture dry completely.

5. Ask the children to paint their sculptures using the following method:

 • First paint the entire sculpture with the main colour of the object.
 • Let the paint dry.
 • Then paint or use a marker to add any details.
 • Add any extra objects for detail.

6. Display the Pop Art sculptures.

Claes Oldenburg

Claes Oldenburg, born in 1929, is one of Pop Art's creative artists. Pop Art became popular during the late 1960s. Pop artists took familiar objects from society and made a statement about them by including these regular objects in their artwork. Oldenburg is well known for his larger-than-life sculptures of everyday objects. He made a giant hamburger that is six feet wide and a bag of shoestring potatoes that is nine feet tall. Oldenburg first makes a life-size model, sculpts the large object out of fabric and then paints it. Other objects included in his sculptures are a telephone, scissors, an ice bag and a large spoon with a cherry on it. These ordinary objects became extraordinary sculptures.

National Curriculum: Art & design
KS1: 1b, 2a, 2b, 2c, 3a, 4a, 4b, 4c, 5b, 5c, 5d
KS2: 1b, 2a, 2b, 2c, 3a, 4a, 4b, 4c, 5b, 5c, 5d

QCA Schemes: Art & design
Unit 1C – What is sculpture?
Unit 3C – Can we change places?

Scottish 5-14 Guidelines: Art & design
Using materials, techniques, skills and media:
Using media; Using visual elements
Expressing feelings, ideas, thoughts
and solutions: Creating and designing;
Communicating
Evaluating and appreciating: Observing,
reflecting, describing and responding

Bark paintings

Age range: 5-11 years

Materials

- example of Aboriginal bark paintings

For each child:

- brown paper bag
- 30.5 x 46 cm brown card
- pencil
- scissors
- glue
- coloured chalk
- tissues
- oil pastels in tan, brown, white, yellow, red and black

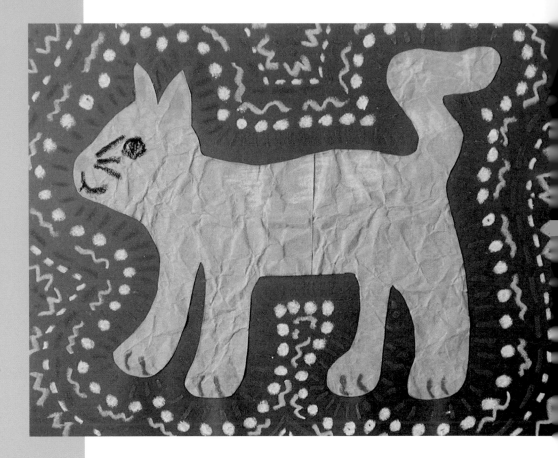

1, 2

3

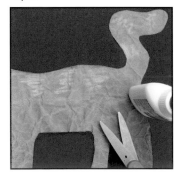
4, 5

6

Art elements

Line

Shape

Colour

Tone

Texture

Talk about...

Talk about Aboriginal bark paintings. Show some examples and point out the use of circles and dots.

Steps to follow

1. Ask the children to cut out the front or back panel of a brown bag then to crumple and uncrumple it several times to create a bark effect.

2. On the bark, ask the children to make a pencil outline (contour) drawing of the animal they would like to have in their painting.

3. They should then lightly rub their choice of chalk onto their animal to fill the entire shape and blend the chalk into the paper with a tissue.

4. Ask the children to cut out their animal along the lines of their pencil drawing and glue it in the centre of the brown card.

5. Using oil pastels, ask the children to add details to their animals.

6. Talk about lines and circles. Encourage the children to think about how lines can symbolize feelings or characteristics such as loud, soft, nice or mean. List examples on the board for reference. Ask the children to decide what feeling they want to express about their animals. Using lines and circles that express that feeling, ask them to make a design around the animal with oil pastels. For example, a picture of a grizzly bear might be surrounded by zigzag lines representing its growl. A snake might be surrounded by wavy lines representing the way it moves. The children should completely fill the areas around the animal with patterns of lines and circles.

Australian Aborigines

The Aborigine peoples of Australia created an art form called bark painting. Originally these paintings were not meant to be a work of art, but rather a form of communication. The paintings were created to tell stories. A distinctive quality of these bark paintings is the use of repetitive dots and circles. Pigments from natural sources like plants were painted on the bark of the eucalyptus tree. The pigments were usually brown, white, tan, yellow, red and black. Contemporary art from Australia includes acrylic paints instead of the natural pigments.

National Curriculum: Art & design
KS1: 1a, 1b, 2a, 2b, 2c, 4a, 4b, 4c, 5b, 5c, 5d
KS2: 1a, 1b, 2a, 2b, 2c, 4a, 4b, 4c, 5b, 5c, 5d
QCA Schemes: Art & design
Unit 1B – Investigating materials
Unit 2B – Mother Nature, designer
Unit 3B – Investigating pattern
Scottish 5-14 Guidelines: Art & design
Using materials, techniques, skills and media: Using media; Using visual elements
Expressing feelings, ideas, thoughts and solutions: Creating and designing; Communicating
Evaluating and appreciating: Observing, reflecting, describing and responding

Mosaics

Age range: 5-11 years

Materials

- photographs of mosaics

For each child:

- 23 x 30.5 cm black card
- scraps of paper and magazine pages cut into small squares
- glue or glue stick
- pencil

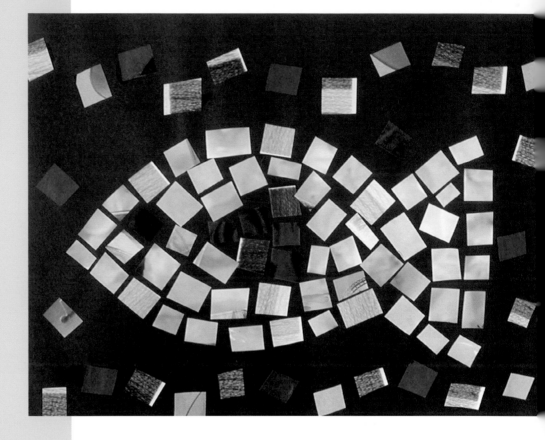

2

3

4

Art elements

Shape

Colour

Tone

Texture

Space

Talk about...

Show the children examples of mosaics. Ask them if they have seen any simple mosaics in their home (for example in tile patterns in the kitchen or bathroom). Of course, the mosaics we find in our homes are much simpler than the mosaics created during the Middle Ages. The Romans used brilliant colours of glass to create their mosaics.

Steps to follow

1. Let the children pick a topic for their mosaic. It could be an animal, a person or a simple design.

2. Ask them to lightly sketch their chosen design on the black card.

3. Let the children choose the colours of cut-paper squares they need for their picture. Ask them to lay out the paper squares on the black paper to create their image. Encourage them to leave a black border around each tile to represent the mortar that holds all the pieces together in a real mosaic. The children should use their knowledge of tone and placement to create space in their pictures.

4. Once the images are laid out as desired, the children can glue their pieces in place.

Roman tile workers

Mosaics are created by using different-coloured tiles to make an image. The tiles are usually laid in mortar to keep them in place. They were used by the Romans to decorate their cathedrals and churches. The tiles used included bits of glass, stone and gold. Often the subject matter focused on religious and political images because that was what was important to the people of the Roman culture.

National Curriculum: Art & design
KS1: 1a, 1b, 2a, 2b, 2c, 4a, 4b, 4c, 5b, 5c, 5d
KS2: 1a, 1b, 2a, 2b, 2c, 4a, 4b, 4c, 5b, 5c, 5d
QCA Schemes: Art & design
Unit 1B – Investigating materials
Scottish 5-14 Guidelines: Art & design
Using materials, techniques, skills and media:
Using media; Using visual elements
Expressing feelings, ideas, thoughts
and solutions: Creating and designing;
Communicating
Evaluating and appreciating: Observing,
reflecting, describing and responding

Flowers

Age range: 5-11 years

Materials

- reproductions of Georgia O'Keefe's artwork

For each child:

- pictures of flowers from bulb catalogues
- 46 x 61 cm white drawing paper
- pencil
- coloured chalk
- tissues
- spray fixative

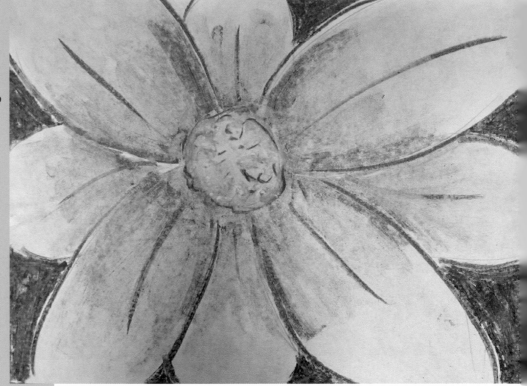

2

4

5

Art elements

Line

Shape

Colour

Tone

Space

Talk about...

Talk about Georgia O'Keefe and show several examples of her flower paintings. Ask:

- Do O'Keefe's flowers fill the page and touch the edges or are they small and in the centre of the page?
- Did O'Keefe use one flower or a bunch of flowers?
- Do the flowers look real or abstract?
- How does she make the flowers look real?

Steps to follow

1. After examining Georgia O'Keefe's flowers, let the children choose a picture of a flower they would like to create in her style. They might like to look at pictures in a bulb catalogue for inspiration.

2. Using a pencil VERY LIGHTLY, ask the children to draw one flower to fill the entire paper. The drawing must touch all four sides of the paper. Point out to the children that by drawing their flower, they are using line and shape.

3. Demonstrate how to use the coloured chalk lightly in some areas and darker in other areas to create space in the flower. Inside the flower will be darker, while the outer areas of the petals that are in the light will be lighter. Give the children tissues to lightly blend the chalk. By using different tones, the children will create space in their drawings.

4. Ask the children to add colour to their flowers with the coloured chalk.

5. Once the flowers are completed, ask the children to name their flower's predominant colour. They should then choose the complementary colour from the colour wheel to fill in the background.

6. Spray the drawings with spray fixative to set the chalk and then display the beautiful flowers.

Georgia O'Keefe

Georgia O'Keefe is one of America's greatest painters. She was born in Wisconsin in 1887 and died in 1986. At the age of 12, Georgia's mother signed her up for painting lessons. Georgia decided to become an artist. She wanted to create art that was personal and expressed her feelings. Later on, Georgia moved to New York to go to art school. In 1924 she began to paint flowers. She painted them big and colourful so that the busy New Yorkers would stop and take time to look at them.

National Curriculum: Art & design
KS1: 1a, 1b, 2a, 2b, 2c, 4a, 4b, 4c, 5b, 5c, 5d
KS2: 1a, 1b, 1c, 2a, 2b, 2c, 4a, 4b, 4c, 5b, 5c, 5d

QCA Schemes: Art & design
Unit 2B – Mother Nature, designer
Unit 5A – Objects and meanings

Scottish 5-14 Guidelines: Art & design
Using materials, techniques, skills and media: Investigating visually and recording; Using media; Using visual elements
Expressing feelings, ideas, thoughts and solutions: Creating and designing; Communicating
Evaluating and appreciating: Observing, reflecting, describing and responding

Pop art food posters

Materials

- examples of artwork by Andy Warhol and Roy Lichtenstein

For each child:

- 23 x 30.5 cm white card
- pencil
- black permanent fine-tipped pen
- watercolour pens in assorted colours
- ruler

1, 2

3

4

Art elements

Line

Shape

Colour

Tone

Texture

Talk about...

Show the examples of artwork by Andy Warhol and Roy Lichtenstein. Ask the children what images these artists might use if they were taking popular items from today's culture. Talk about the dots in Lichtenstein's artwork. Let the children practise making dots with the tips of the coloured markers on a piece of practice paper. Notice that the dots close together give a darker tone than the dots placed farther apart. When two colours of dots are mixed, the colours change.

Steps to follow

1. Ask each child to choose a food item then to make a contour line drawing (outside line only, no fill or shading) of their food in pencil. The food item should fill the page.

2. Ask the children to trace over their pencil lines with fine-tipped black markers.

3. Let the children add colour to their drawings by drawing dots with the markers. Reiterate that they must use dots. They can create tone by using the dots close together or far apart and can mix dots to create different colours. They can also use dots in different ways to give their drawing texture.

4. Ask the children to pick one or two colours that contrast with their food then to draw in coloured stripes to fill in the background.

5. Let the children sign their artwork and then display it.

Andy Warhol and Roy Lichtenstein

In the 1960s, Pop Art became popular. Pop artists used items that were familiar and made a statement about them. Two of the most famous Pop artists were Andy Warhol and Roy Lichtenstein. Andy Warhol used a photo silk-screening process to put images from the media onto his large canvases. He is known for his repeated use of the same image. Some of his most famous works show Marilyn Monroe, Elvis, Campbell's soup cans and money. Roy Lichtenstein painted his images in the style of a comic strip. His paintings are made up of dots to imitate the Benday dots used to mass print images in books and papers.

National Curriculum: Art & design
KS2: 1a, 1b, 1c, 2a, 2b, 2c, 4a, 4b, 4c, 5b, 5c, 5d
QCA Schemes: Art & design
Unit 5A – Objects and meanings
Scottish 5-14 Guidelines: Art & design
Using materials, techniques, skills and media: Using media; Using visual elements
Expressing feelings, ideas, thoughts and solutions: Creating and designing; Communicating
Evaluating and appreciating: Observing, reflecting, describing and responding

Self-portraits

Age range: 5-11 years

Materials

- examples of self-portraits by Vincent Van Gogh

For each child:

- two 30.5 x 35.5 cm pieces of card
- pencil
- black fine-tipped permanent marker pen
- hand mirrors
- paintbrush
- foam egg carton
- thick tempera paint (mix 1 tablespoon of flour with each half cup of paint – paint colours are needed for skin tones, hair, eye, lip, and clothing colours)
- torn bits of coloured tissue paper
- white glue
- scissors

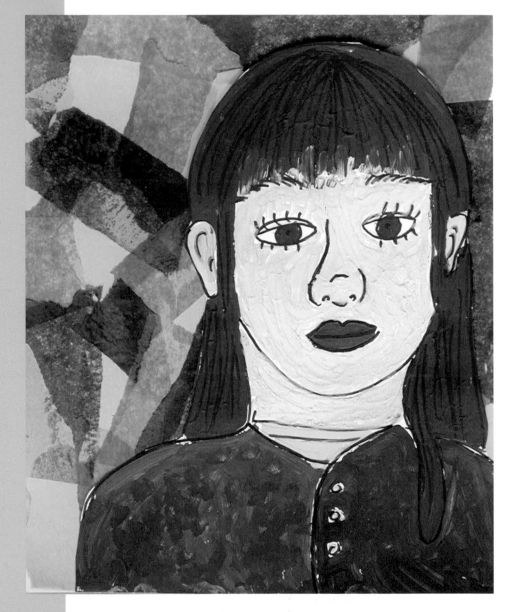

1

2, 3

5

6

Art elements

Line

Shape

Colour

Texture

Talk about...

Show the examples of Vincent Van Gogh's self-portraits. Point out Van Gogh's use of thick paint and explain the term impasto. Ask the children to notice Van Gogh's expression, his position and the texture created by the impasto.

Steps to follow

1. Give each child a piece of card and a mirror. Ask them to look in the mirror and use a pencil to draw themselves from the shoulders up. Remind them to fill the page. They should make sure that their bodies go off the bottom of the paper and that their heads almost touch the top of the paper.

2. Using a paintbrush, ask the children to apply thickened paint to the faces, eyes, lips, hair and clothes on the self-portrait to give it a more textured look. Let the paint dry.

3. Ask the children to trace over the portrait lines with the black marker pen.

4. Ask them to cut out the self-portraits.

5. Using watered-down glue and a brush, ask the children to cover a second sheet of card with torn bits of tissue paper. The pieces should overlap one another. Suggest that the children pick a colour family (warm or cool) and keep their background in that family.

6. When the tissue paper is dry, the children can glue their self-portraits onto the background.

7. Let the children sign their artwork and it is ready for display.

Vincent Van Gogh

Vincent Van Gogh was not well known during his lifetime, but he is now regarded as one of the world's greatest artists. Vincent was a sad man and did not smile in his self-portraits, though he painted several of them. During his painting career, Van Gogh sold one painting for about £50. Today his paintings, using thick paint and colours straight out of the tube, are worth millions. This thick or heavy use of paint showing the marks of the brush is known as Impasto. Vincent Van Gogh used impasto to add feelings and emotions in his paintings.

National Curriculum: Art & design
KS1: 1a, 1b, 2a, 2b, 2c, 4a, 4b, 4c, 5b, 5c, 5d
KS2: 1a, 1b, 2a, 2b, 2c, 4a, 4b, 4c, 5b, 5c, 5d
QCA Schemes: Art & design
Unit 1A – Self portrait
Unit 3B – Investigating pattern
Scottish 5-14 Guidelines: Art & design
Using materials, techniques, skills and media:
Using media; Using visual elements
Expressing feelings, ideas, thoughts and solutions: Creating and designing; Communicating
Evaluating and appreciating: Observing, reflecting, describing and responding

Gargoyles

Age range: 5-11 years

Materials

- photographs and pictures of gargoyles and Gothic architecture

For each child:

- clay

- texture tools such as nails, craft sticks, toothpicks

- grey tempera paint

- paintbrush

1

2

6

Art elements

Form

Texture

Talk about...

Talk about gargoyles with children. Show pictures of Gothic architecture and gargoyles.

Steps to follow

1. Help the children to make gargoyles from the clay using a pinch-pull technique. Start each child off with a block or ball of clay. Keeping the clay all in one piece, the children should use their fingers to pull and pinch the clay into a creature. They might want to pull out legs, wings and a head.

2. Encourage the children to experiment with texture tools to press in and draw details on the basic gargoyle form. The head of a nail or the rounded end of a wooden craft stick makes good scales when pressed in repeatedly.

3. Ask the children to hollow out the bottom of their gargoyles so they can dry more quickly.

4. Ask the children to add their names to the bottom of their gargoyles.

5. Let the clay dry and then fire or bake according to the clay manufacturer's directions.

6. Ask the children to paint their gargoyles grey to make them look like stone.

Medieval architects and builders

Medieval architects and builders included ornate gargoyles as part of the buildings they designed and built. Gargoyles are stone figures found mainly on the top of Gothic-style buildings. Because they were originally used as drains on castles and churches, the gargoyles' mouths were usually open. Gargoyles were also believed to scare off evil spirits from the buildings they were placed upon. They fit in well with the ornate decoration of the time. Usually, gargoyles are in the form of made-up creatures.

National Curriculum: Art & design
KS1: 1b, 2a, 2b, 2c, 3a, 4a, 4b, 4c, 5b, 5c, 5d
KS2: 1b, 2a, 2b, 2c, 3a, 4a, 4b, 4c, 5b, 5c, 5d

QCA Schemes: Art & design
Unit 1C – What is sculpture?
Unit 2C – Can buildings speak?
Unit 3C – Can we change places?

Scottish 5-14 Guidelines: Art & design
Using materials, techniques, skills and media: Investigating visually and recording; Using media; Using visual elements
Expressing feelings, ideas, thoughts and solutions: Creating and designing; Communicating
Evaluating and appreciating: Observing, reflecting, describing and responding

GLOSSARY

Words you need to know

Complementary colours – colours that are straight across from each other on the colour wheel

Contrast – using light colours next to dark colours

Cool colours – colours that have cool undertones: green, blue and purple

Diagonal – a slanted line

Form – a three-dimensional object

Geometric shape – a shape that fits into mathematics (for example circle, square, rectangle, triangle)

Horizon line – a horizontal line used to represent the horizon in a one-point perspective drawing

Horizontal – a straight line that runs from side to side

Hue – the colours of the colour wheel

Line – a basic element of art; the path made by a moving point

Monochromatic – using one colour in an image

Organic shape – a shape that comes from nature and does not fit into mathematics

Parallel lines – two lines that run next to each other and never intersect

Primary colours – colours that cannot be made by mixing other colours: red, yellow and blue

Secondary colours – colours that are made by mixing two primary colours: orange, green and purple

Shade – a variety of a particular colour with black added

Shape – a basic element of art; an area that is made by a line that touches at the beginning and end

Tertiary colours – colours that are made by mixing one primary and one secondary colour. These colours tend to be greyish. The primary colour is always listed first: red-orange, yellow-orange, yellow-green, blue-green, blue-violet, red-violet.

Tint – a variety of a particular colour with white added

Tone – the use of lights and darks in artwork

Vanishing point – the single point at which all images vanish in a one-point perspective drawing

Vertical – a straight up and down line

Warm colours – colours that have warm undertones: red, orange, and yellow

Creative Activities • How to Teach Art to Children • www.scholastic.co.uk